NORWICH
in the 1950s
Ten Years that Changed a City

PETE GOODRUM

AMBERLEY

For Sue

Front cover photograph courtesy of Archant

First published 2012

Amberley Publishing
The Hill, Stroud
Gloucestershire, GL5 4EP

www.amberley-books.com

British Library Cataloguing in Publication Data.
A catalogue record for this book is available from the British Library.

ISBN 978 1 4456 0906 5

Typeset in 10pt on 12pt Sabon.
Typesetting and Origination by Amberley Publishing.
Printed in the UK.

CONTENTS

ABOUT THE AUTHOR

Pete Goodrum is a writer, born and bred in Norwich. His background is advertising and he has worked on national and international campaigns.

Pete now operates as a freelance writer, broadcaster and consultant. He writes advertising copy as well as contributing articles and columns to magazines.

Pete also makes frequent appearances on BBC local radio covering topics ranging from advertising history to social trends. His own show, *Backtrack*, is broadcast on Future Radio.

A regular reader at live poetry sessions, and actively involved in the media, Pete has a real passion for the history of Norwich and Norfolk.

He lives in the centre of the city with his wife Sue, and their three cats and one dog.

Norwich in the 1950s. Using archive photographs and contemporary material, Pete Goodrum takes a different and fascinating look at the city as it developed through a decade of change.

INTRODUCTION

Mention the 1950s and for some it's a flashback to a decade of black and white austerity, bomb sites and rationing. For others it's an instant reminder of rock and roll. A time of Teddy Boys and coffee bars, jukeboxes and jiving. Poised halfway through the twentieth century, the decade is a fulcrum for post-war life. To be born in 1950 made you a teenager of the '60s with no memory of war but a future full of Beatles and the race to the moon. To be in your sixties in 1950 meant that you'd had a Victorian childhood. As a ten-year-old you too would have had no conception of a World War, let alone one that would wreak havoc on the civilian population. And yet, by 1950, you would have lived through two global conflicts and witnessed the bombing of our cities. A child of ten in 1900 could never have imagined the civilian deaths of the 1942 air raids on Norwich.

Three years after that brutal blitz there was a plan for the future. The 1945 Plan for Norwich was, and remains, a controversial document. Much of it would never come to fruition. Some of it would eventually be realised as late as the 1960s.

What happened in between was the 1950s. Survivors of the war, and those born after it, would see Norwich change as it came to terms with peace and hoped for prosperity.

Birthplace of Barclays, Aviva, Start-rite, Caleys and Colman's, the city was ready to embark on another chapter in its long history of commercial and cultural development.

By the end of the decade the retail heart of the city would be reconstructed, its new developments would be changing domestic life and its manufacturing industries would be making world-class products with household names.

From the austerity of the fledgling peace to the arrival of the consumer society, Norwich embraced the 1950s as a decade of change.

ACKNOWLEDGEMENTS

I have many people to thank for their help in producing this book.

Firstly I am hugely grateful to Jonathan Plunkett who, when I asked him if I could use his father George's photographs, gave me his instant blessing. The extraordinary pictures that George Plunkett took of Norwich, over many decades, are a wonderful archive.

I have to give special thanks to Archant. In particular Gary Attfield, Rosemary Dixon, Siofra Connor and Steve Adams for their generosity and help in allowing me the use of their library. Also at Archant, I have to thank Chris Lacey at the 'Pink 'Un' for permission to reproduce some cuttings.

Jamie Arnall at Norwich City Football Club kindly approved the content relating to the club. Anna Stone at Aviva deserves thanks for allowing the use of Norwich Union advertising, as does Krista Marsden at Britvic for their permission to feature the Robinsons brand. Grateful thanks to Roger King at Caleys for permission to include the Fortune advertisement.

Thanks are also due to Michelle Jarrold and Jane French at Jarrolds for their help.

I'm grateful to my good friends Rita and Kevin Baker for the loan of invaluable reference material.

The images used on pages 7, 9, 39 and 89 are © Christopher Reeve.

Thanks to Pete Huggins for the photograph of The Forum. The colour photograph of Gentlemans Walk is reproduced courtesy of the University of East Anglia. A word of thanks to Dave Guttridge for his help. The bus station regeneration project picture is courtesy of NPS Graphics, NPS Group Ltd.

Wherever possible, photographs have been credited to those who own the copyright. Every effort has been made to trace the ownership of material, although obviously some of the organisations no longer exist. If I have failed to find you, and you see something in this book that relates to you, I sincerely hope that you recognise that everything has been used with affection and respect.

Needless to say I'm grateful for the support I've had from Nicola Gale and all the team at Amberley Publishing.

I must thank my father, Geoffrey Goodrum, for letting me plunder his archives. Thanks Dad.

And finally, my sincere thanks to my wife Sue for her constant help, support and quite simply putting up with me. I couldn't have done it without you.

1

A Plan for Peacetime Norwich

Five years before the dawn of the 1950s there was a plan for post-war Norwich. 'The City of Norwich Plan 1945' had in fact been worked on before the war. Maps for dealing with the undeveloped areas of the city had been published as early as 1928 and a scheme to cover the built-up zones was well underway when war broke out in 1939.

The 1945 Plan was strategic and visionary as well as being tactical and detailed. It contained breathtaking concepts such as a viaduct sweeping from Braticondale to Clarence Road, but only twenty pages later it was criticising the use of three different styles of lettering on a pub in Pottergate. Similarly, it expresses opinions on the vulgarity of enamel advertising signs, but it also sets out proposals for an entire new ring-road.

Almost inevitably resorting to using the 'Fine City' quote from George Borrow, the authors also quoted Burns' famous lines, 'O wad some pow'r the giftie gie us, To see ourselves as others see us!' This was in reference to the supposed proliferation of advertising signs on main-road corner plots, and the less-than-favourable impression they might make on visitors. Advertising comes in for regular criticism throughout, along with architectural design and the 'dullness' of nineteenth-century terraced housing. 'Good' design is often represented with photographs of developments in other parts of the country.

Published as a large-format book, produced by Jarrolds, the Plan juxtaposed photographs of war-damaged Norwich with stylish 'artist's impression' drawings of the envisioned future. The 136 pages of maps, diagrams and opinions carried a foreword from Norman Tillet, chairman of the Town Planning Committee. He quoted Aristotle by saying that 'men come together in cities in order to live; they remain together in order to live the good life'. He goes on to say that he believes that the Plan will 'stand for many years to come as an outstanding contribution to that design within which our citizens will seek, and will find, the road to the Good Life. For that reason I respectfully commend it to your notice.'

Whilst in reality 'The City of Norwich Plan 1945' never came to full fruition, it did sow the seeds for change, and an attitude to change that would characterise the years that followed its publication.

The biggest catalyst for redevelopment, however, was sheer necessity. The pre-war planners could never have known that bomb damage would, with supreme irony, create a massive opportunity to restructure the city. By 1945 it was painfully obvious that something had to be done.

2

A City Recovering from War

The fact was that while planners and politicians aired their views on the quality of architecture and the vulgarity of advertising signs, the city had been badly damaged by enemy action. The destruction of houses, churches, factories, shops and offices had left visible scars as well as commercial and domestic strain. This may seem a particularly bleak picture of a desolate space but it typifies the bomb site areas that lingered into the 1950s. Near to Barn Road the ancient city walls embrace two eras as they stand between bomb-flattened ground and post-war hoardings advertising readily available whisky.

Nothing was sacred in the blitz. Norwich was bombed over forty times during the war. Historic buildings were specifically targeted in the Baedekker raids of 1942. 30,000 houses were damaged, as were 100 factories. No fewer than seven medieval churches were hit.

In a raid that accounted for the lives of half of the Norwich citizens who would die from bombing of the city, St Bartholomew's and St Benedict's were the first to be destroyed, on 27 April 1942.

By June St Paul's, St Julian's and St Michael at Thorn would all have shared the same fate.

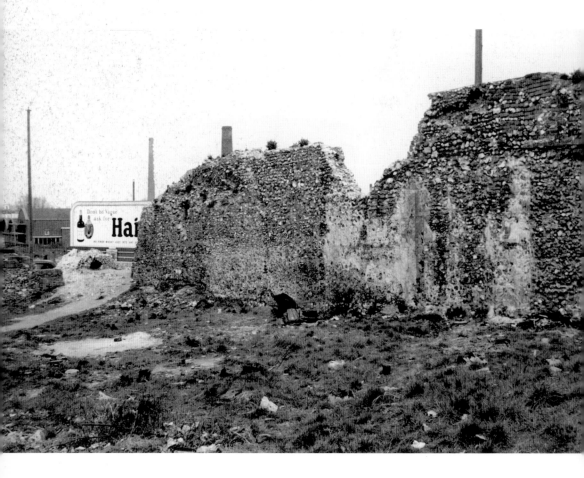

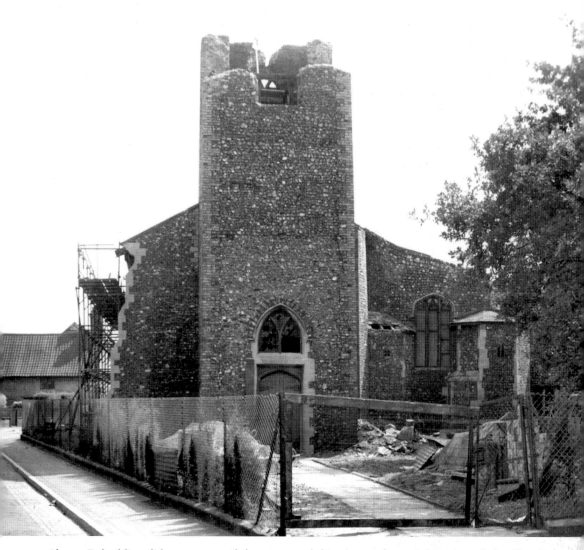

Above: Rebuilding did not start until the 1950s and this picture shows St Martin at Oak still awaiting repair in 1952. Its proximity to the M&GN Railway yards had almost certainly heightened its value as a target. (Photograph by George Plunkett)

Opposite: Children happily played on plots of land like this one, blissfully disregarding not only the visible dangers of the place, but also the possibilities of hidden and unexploded wartime bombs. (Photograph by George Plunkett)

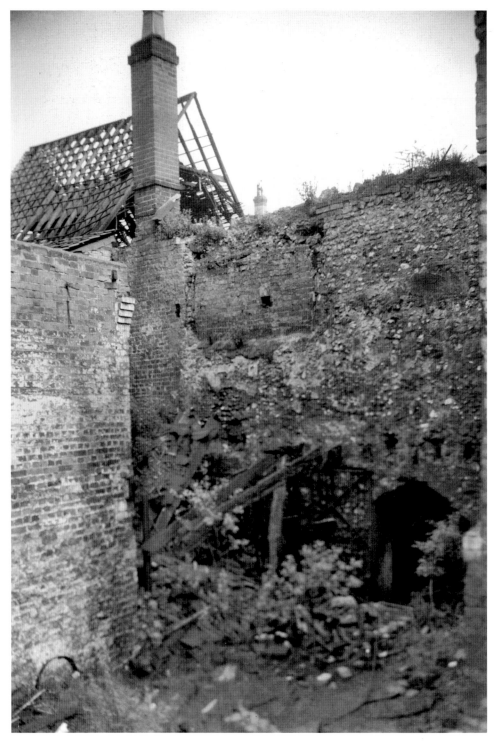

Bomb damage at the rear of Surrey Street was still evident in the 1950s. (Photograph by George Plunkett)

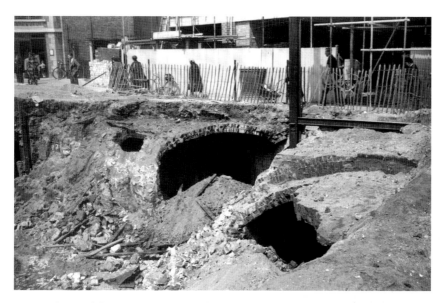

Across the road from Surrey Street, behind St Stephens Street, shoppers were still negotiating the results of air raids when this photograph was taken in 1954. It is known that 2,000 domestic houses were destroyed by bombing in Norwich. Over 27,000 were damaged. There is no official record of how many businesses were lost, but the city centre suffered terribly. Retailers had helped each other with floor space in a spirit of 'pulling together' and by late 1954 there were real signs of progress in the St Stephens Street area. (Photograph by George Plunkett)

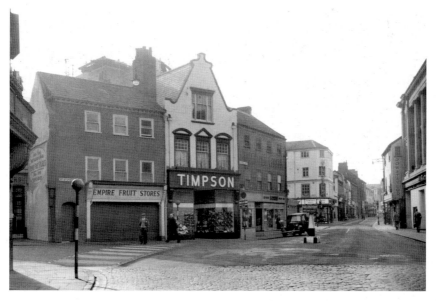

Work had been going on in the Surrey Street area for some time, and not all of it was directly linked to war damage. This picture from 1953 pre-dates most of it and shows a barely recognisable St Stephens Plain and St Stephens Street. (Photograph by George Plunkett)

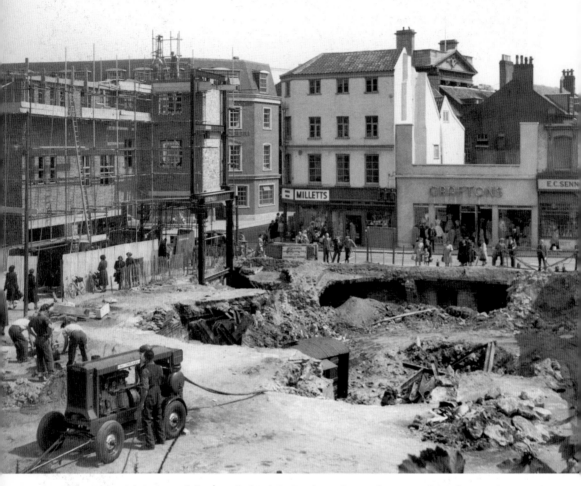

Above: A wider view of the area behind St Stephens Street shows work underway in 1954. (Photograph by George Plunkett)

Opposite: Another shot from the same year shows the start of the demolition project that would have such a dramatic effect on this corner of the city. It's interesting to compare the health and safety precautions of today with those employed in 1953. There appears to be no barrier or nets around the building and flat caps are seemingly the only protective headgear available. (Photograph by George Plunkett)

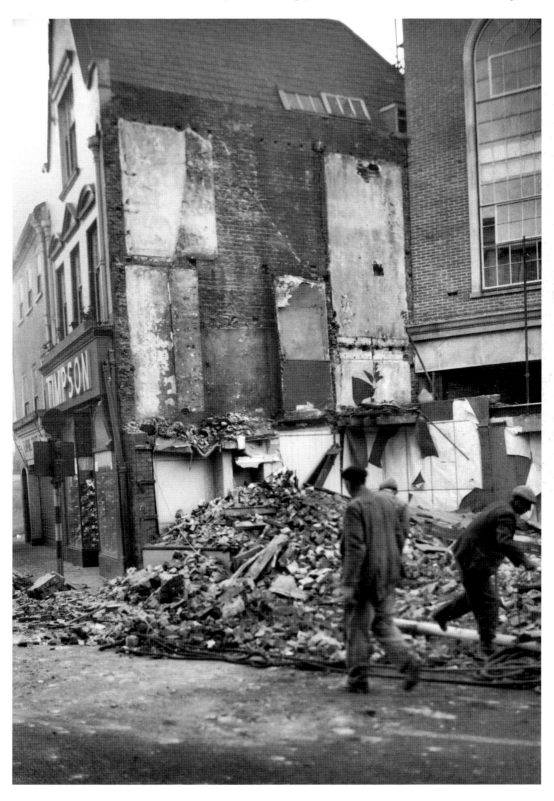

If there is one site that really captures the spirit of the post-war city centre it must be the Curls building. Curls had been a significant Norwich store since the early twentieth century. Established by three brothers in around 1860, the business had grown from a rambling affair based in the old Rampant Horse Inn. By the 1940s Curl Brothers was one of the main retail businesses in Norwich, along with Jarrolds, Garlands, Buntings, Chamberlain's and Bonds. The Curl Brothers excelled at retail and the shop had grown to the point where its building dominated the Orford Place and Brigg Street area.

Its 51,000 square feet of retail floors and restaurants, built up by men born in a previous century, were destroyed in one night in 1942. It was a devastating raid. Pilch's, Buntings and the giant Woolworths all suffered dreadful damage. In a spirit of co-operation that perhaps only such adversity can create, stores and other businesses put aside their competitiveness to help each other. For a time, Curls operated from premises in Westlegate owned by Norwich Union.

No matter how much co-operation and help there was in the business community, no matter how resilient the citizens of Norwich were to bombs and shortages, the city had a giant hole in its heart, and it was a drain on morale.

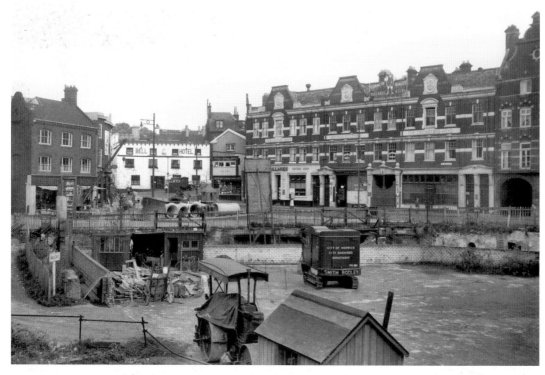

People would wonder 'if the hole would ever be filled in'. It's a sentiment that's easy to understand given that this photograph was taken in October 1953. The great space had been put to use as a water tank, and a car park, but it was well into the 1950s before any signs of the new building appeared. (Photograph by George Plunkett)

Right: It's 1954 and work on the new Curls store finally gets into swing. By this time Woolworths had been rebuilt, and Marks & Spencer had taken over the building once occupied by Buntings. (Photograph by George Plunkett)

Below: A year later and the now familiar shape of the building begins to emerge. (Photograph by George Plunkett)

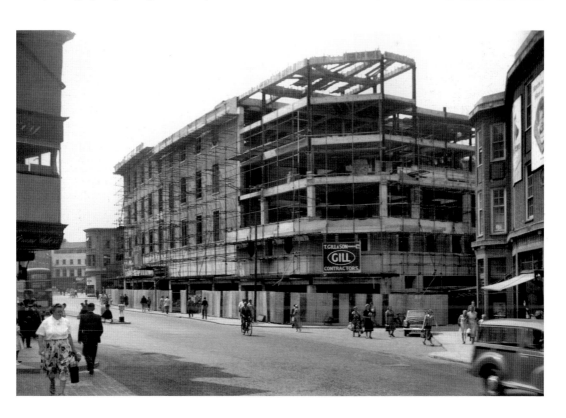

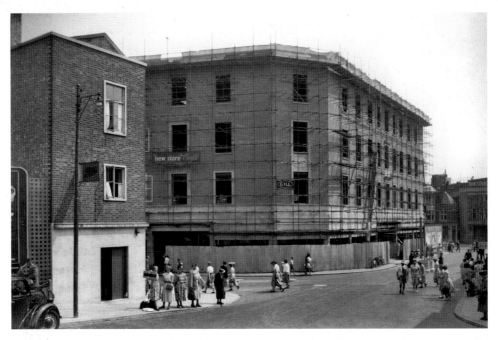

By the summer of 1955 the Curls building is nearing completion. This Brigg Street view really conveys the size of the project, and its impact on the city centre. (Photograph by George Plunkett)

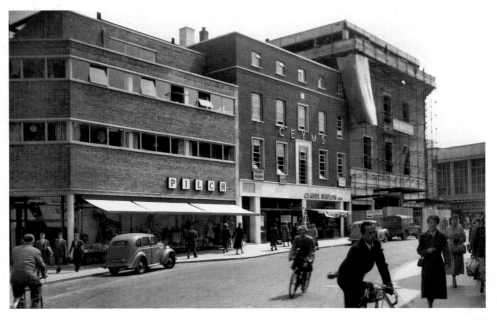

Within weeks of the previous picture it is possible to see not only the almost complete Curls, but also a glimpse of post-war modernity. The rebuilt Pilch shop, the new architecture and typography show that the city is reinventing itself. For all the excitement of the 1950s there is a decided calm about Brigg Street in this shot. (Photograph by George Plunkett)

3
SOME THINGS
DON'T CHANGE

Changes borne of necessity were being made in 1950s Norwich. Some faster than others. It would be wrong to paint a picture of total and restless upheaval. Despite the war there were parts of the city that remained steadfastly unaltered, creating a contrast of unashamedly changed and steadfastly the same.

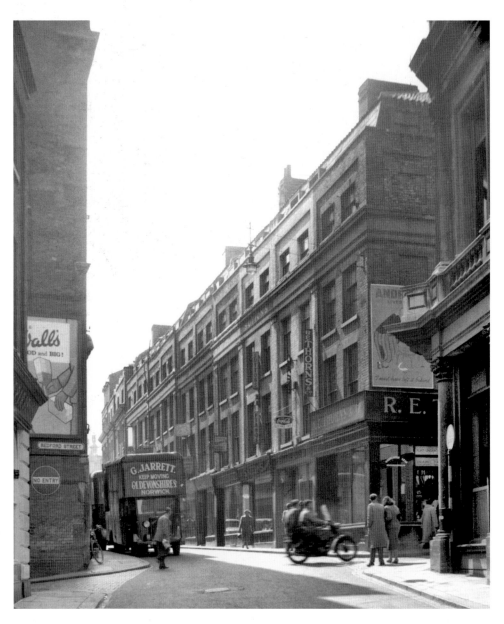

This view of Exchange Street is from 1956, but were it not for the lorry it would be difficult to date within a decade. Although the street will see a lot of change further towards St Andrews, at this junction with Bedford Street and Lobster Lane there's little sign of the emerging new city. (Photograph by George Plunkett)

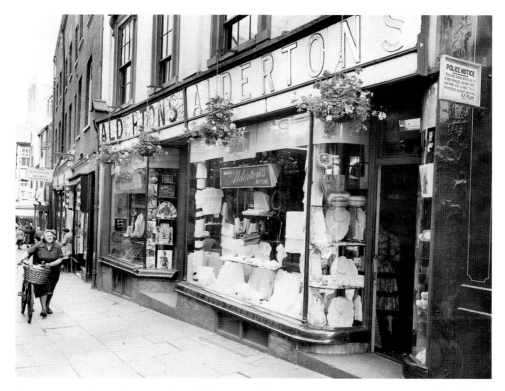

Swan Lane in the mid-1950s shows little sign of change. Today we cherish the character of the area known as 'The Lanes' but, with Brigg Street and Orford Place representing the new era, these streets must have seemed a little 'behind the times' during the '50s. (Photograph courtesy of Archant)

Conservation of the city was, however, already a matter of serious debate. And never more so than on the issue of Tombland in 1951.

The Norwich Society had enjoyed a good relationship with the City Council since the end of the war. Tensions emerged when the Council revealed their plans for Tombland.

Once the Saxon marketplace of Norwich, Tombland had, by 1951, acquired some wooden stalls selling sweets, cigarettes and newspapers. It could be argued that these were in keeping with the location's history as a market. But, presumably with the Festival of Britain and royal visits on their minds, the Council decided to 'tidy up' the place.

This involved laying down some brick and concrete foundations, on which to place new structures which would replace the existing 'shanty-type' stalls.

The Norwich Society swung into action. 'Tombland,' they said, 'was a fine and beautiful square which should be kept open, and that the decisions made by the Norwich City Council to construct buildings there on permanent foundations was an infraction of rights the citizens had held ever since Saxon times.'

Tombland, 1951. (Photograph by George Plunkett)

The Society sought help from the Georgian Group, and the Commons, Footpaths & Open Spaces Preservation Society. They protested to the Minister of Town and Country Planning. It was to no avail; the minister refused to intervene. Defeat was not an option for the Norwich Society.

With limited financial resources it sought a writ, in the name of Arnold Kent, its treasurer, and promptly took Norwich City Council to the High Court. The judgement was historic. Mr Justice Vaisey found in favour of the Society, and the Council accepted the judgement with no further challenge.

The Norwich Society was understandably emboldened. Unashamedly adding Tombland to previous victories, which included saving Elm Hill, and the Assembly House, they issued a leaflet aimed at recruiting new members. 'For a fairer City the Norwich Society has saved Tombland from encroachment,' it said. 'Help this work by becoming a member of the Society.'

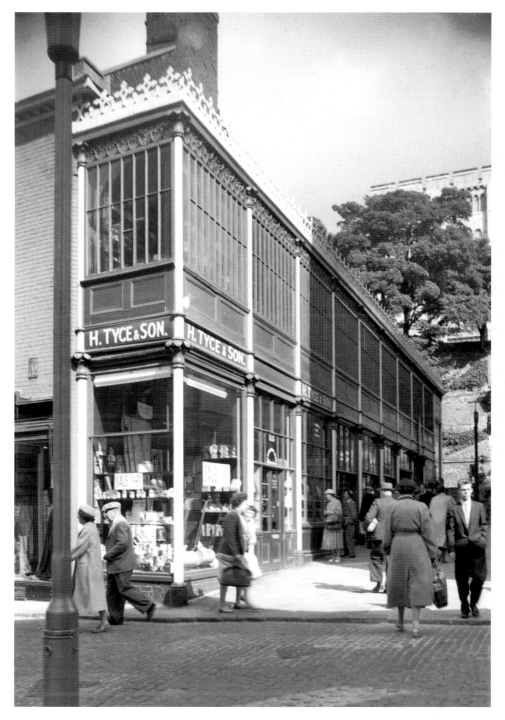

The 1950s haven't brought much change in Davey Place. The remarkable nineteenth-century iron shopfront of Tyce & Son is still in place in 1959. (Photograph by George Plunkett)

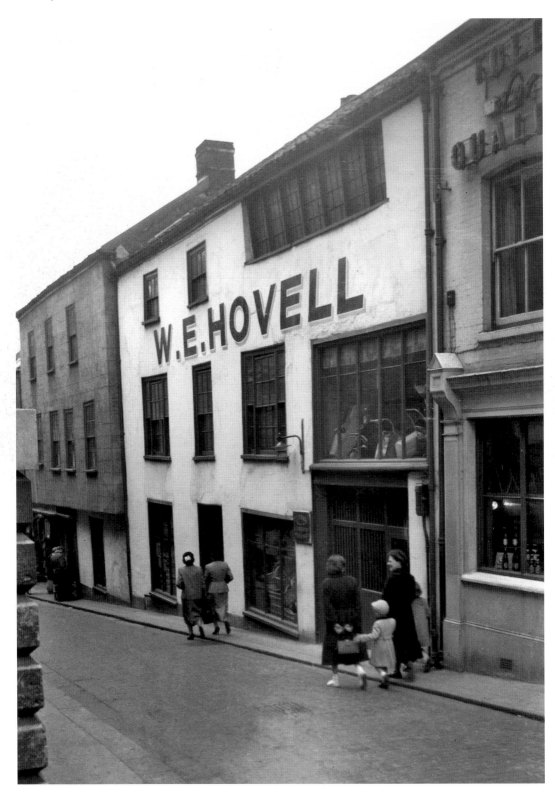

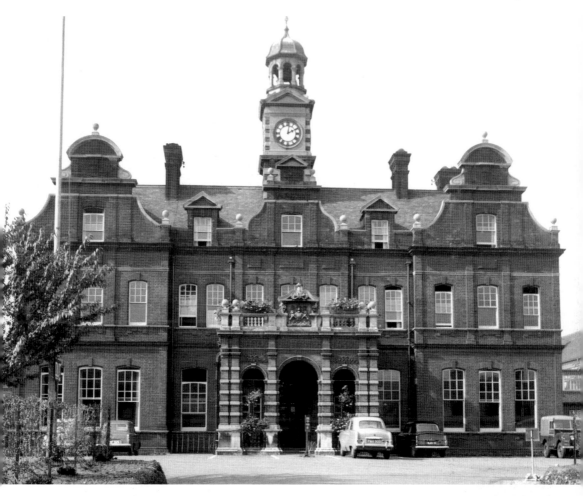

Above: In the mid-1950s some of the buildings and resources that would become famous for their later reincarnations were still in their original forms. The Norfolk and Norwich Hospital was still operational, inside the city and in its Victorian building. (Photograph by George Plunkett)

Opposite: Bedford Street, home for many years to Hovells, had not altered much in centuries. The weavers' window is still clearly visible in the ancient building in this 1955 view. (Photograph by George Plunkett)

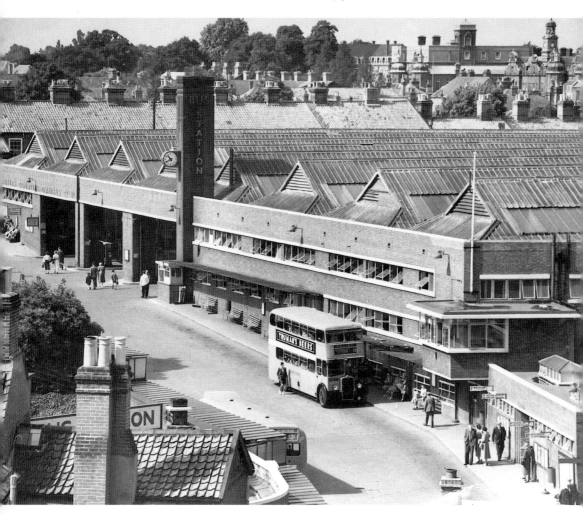

The bus station, however, has undergone more obvious structural and design changes since then. (Photograph courtesy of Archant)

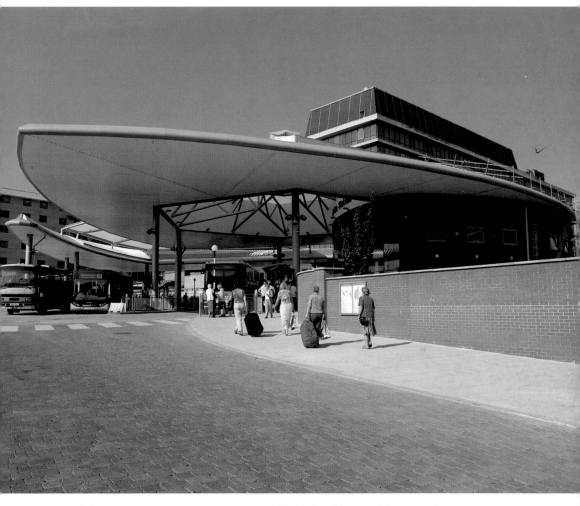

Norwich bus station, 2012. (Picture courtesy of NPS Graphics, NPS Group Ltd)

The Forum. Central to modern Norwich, this stunning building rose from the ashes of the 1960s library. (Photograph courtesy of Pete Huggins)

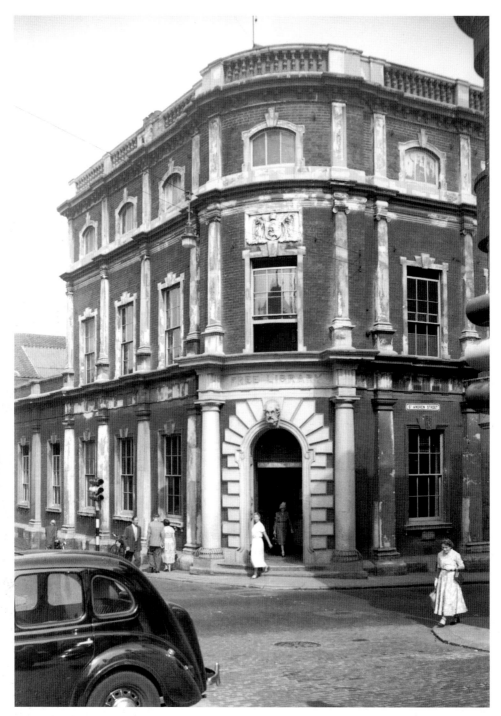

On the corner of Exchange Street the old library was still in service. Fondly remembered by many as a place of utter silence and strict rules, it remained in use until the new library was built in 1962. Nobody could have foreseen that the new premises would have a relatively short life, burning down in 1994. (Photograph by George Plunkett)

4

THE ROYAL CONNECTION AND THE FESTIVAL OF BRITAIN

The 1950s arrived with tremendous optimism, but there was sadness too. On 6 February 1952, King George VI died. This momentous event had enormous local resonance. He was a Norfolk man, and he died in Norfolk, at York Cottage on the Sandringham Estate.

On 11 February, thousands turned out to pay their respects as his body was taken by train to King's Cross. Although not yet crowned, the Princess Elizabeth was now queen, ushering in a new era.

Her sister, Margaret, would visit Norwich in July 1952, when it seems the city was already firmly in the national spotlight. In the previous month Richard Dimbleby had made a television documentary called *Come With Me to Norwich* in which he'd visited companies, local VIPs and places of interest.

Amongst those Dimbleby interviewed was Sir Robert Bignold, Head of Norwich Union. He was, it seems, anxious to ensure that Norwich was not lagging behind the times, and that the city was very much part of the new era. In response to Dimbleby's suggestion that 'Norwich likes its history', he very quickly replied, 'Yes, Mr Dimbleby, but we are very progressive. Witness our recovery from the recent war.'

A year earlier, in June 1951, Elizabeth had come to Norwich on one of her final duties before becoming queen, and her first official visit to the city.

Unaware that within two years her coronation would make her the centre of the world's attention, she was, in that June, here to open the Norwich celebrations for the Festival of Britain.

The Festival had been organised by the government to create a feeling of optimism in the aftermath of the war, and to promote Britain's contribution to, and achievements in, science, technology and the arts.

It was inevitably centred on London, but there was a serious effort made to engage the country at large. Norwich was to have its day. The city was selected to produce one of four provincial festivals, and from 18 June to 30 June there was constant activity throughout Norwich.

Princess Elizabeth opened the Festival in Norwich standing on the balcony of City Hall. It was the same spot her father had stood on to open the City Hall in 1938.

She visited the castle and, after lunch at the Assembly House, was driven through the city. The streets were crowded with spectators, their numbers swelled by factory workers given time off to see her. She visited the cathedral, where she was welcomed by the Bishop of Norwich. She would see him again at her coronation.

With the official opening duly completed, the Festival got under way. Parades and processions were very much the order of the day. Many of them were designed to celebrate distinctly local characters and historical events. These included the Romans, Boadicea, Kett, Erpingham and George Borrow, who of course had coined the phrase 'A fine city'.

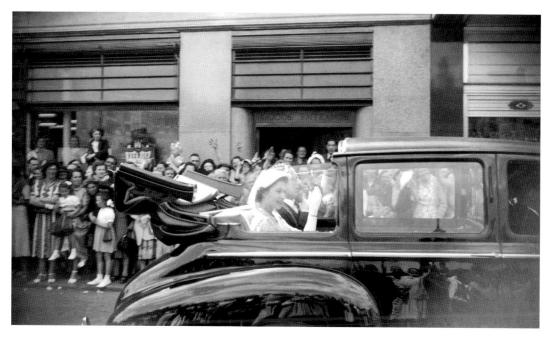

Princess Elizabeth in Rampant Horse Street on her way to lunch at the Assembly House in 1951. (Photograph by George Plunkett)

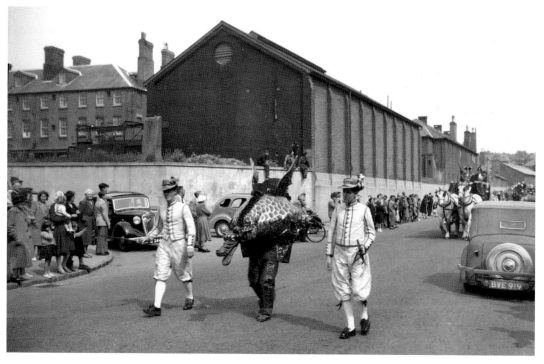

Snap Dragon and Whiffler in the 1951 Norwich Festival of Britain procession. (Photograph by George Plunkett)

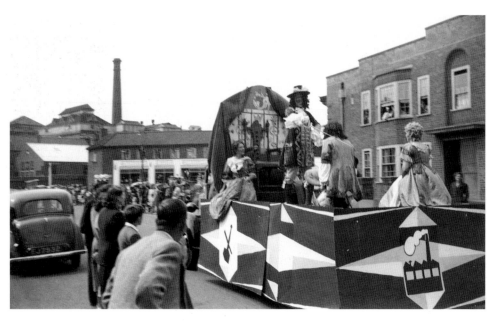

Thomas Browne 'being knighted' in the 1951 Norwich Festival of Britain procession. (Photograph by George Plunkett)

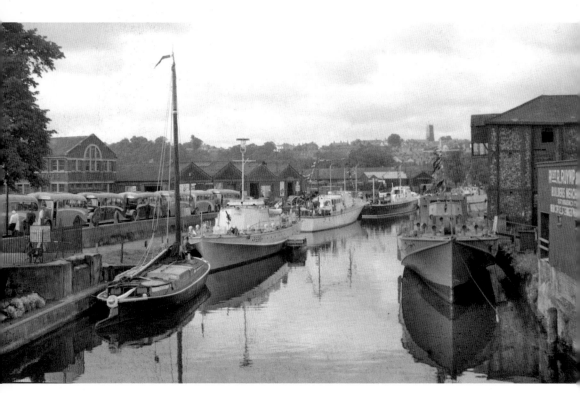

Much of the Festival activity was centred on Riverside, with hospitality tents and visits from naval vessels. (Photograph by George Plunkett)

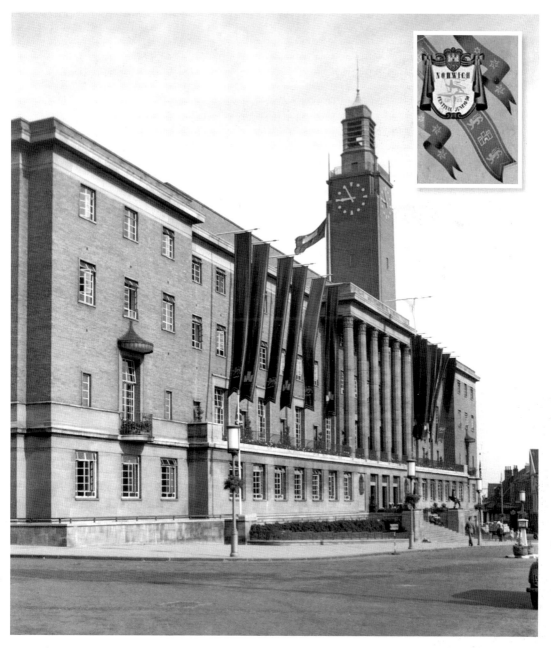

Above: The City Hall lived up to the pageantry of the Festival with impressive banners. (Photograph by George Plunkett)

Inset: Jarrolds had produced the lavish programme for the Festival, which featured theatrical and musical performances as well as dances and more formal lectures. The 200 pages of this book contained a full, day-by-day listing of all the events as well as advertising support from local businesses keen to participate in such a high-profile event. The city seized this opportunity to promote itself, at the same time engendering a feeling of celebration. (Photograph by George Plunkett)

As 1951 drew to a close the country was to undergo more change. Churchill was elected to form a Conservative government in October, and some would say that the new administration distanced itself from the Festival of Britain, seeing it as associated with Atlee's Labour government.

The new government would soon have Norfolk on its agenda, when in 1952 Churchill faced heated questions in the House regarding American Air Force bases in the region. If the Cold War erupted into world conflict, Norfolk did not like the idea of being on the front line of bombing again.

By the following February the king would be dead, making Elizabeth the new queen.

Her coronation took place in June 1953, and of course Norwich celebrated.

At the grandest level, the Bishop of Norwich, The Right Reverend Percy Mark Herbert DD was a member of the coronation procession in Westminster Abbey. At home, street parties, processions, bunting and free ice creams were what it was all about.

Souvenir mugs and plates were given to children and schools organised parties, with civic dignitaries attending some of them.

Television was still a relative rarity in homes at this time. Many people claim that the Coronation was their first experience of the new medium. There was only the BBC, but coverage was expected to create huge audiences by the standard of the day. Those with sets welcomed in neighbours to share the experience of watching Elizabeth crowned.

Newspapers carried warnings and instructions on how to watch the TV! The official advice was that 'the room must be dark. But not blacked out. Have a shaft of light at your back but the screen must be in darkness. Have some ventilation. Move away from the screen occasionally and get some fresh air.'

There was also advice in the media for those planning to travel to London and witness the spectacle in person. It was suggested that one took a cardboard spoon and plate. A solid *Eau de Cologne* stick would prove useful and safe. Taking a stool was not a good idea because the police would confiscate it. For the ladies a non-crushable dress was essential because it would be a long day. And to keep you going you were advised to take a glucose drink. Mentioning brand names was forbidden, but the hint was clear; 'there's one used by convalescents'.

If you were planning to drive to London, Norwich Motor Company had the brand-new Humber eight-seater Pullman limousine on sale for £1,600!

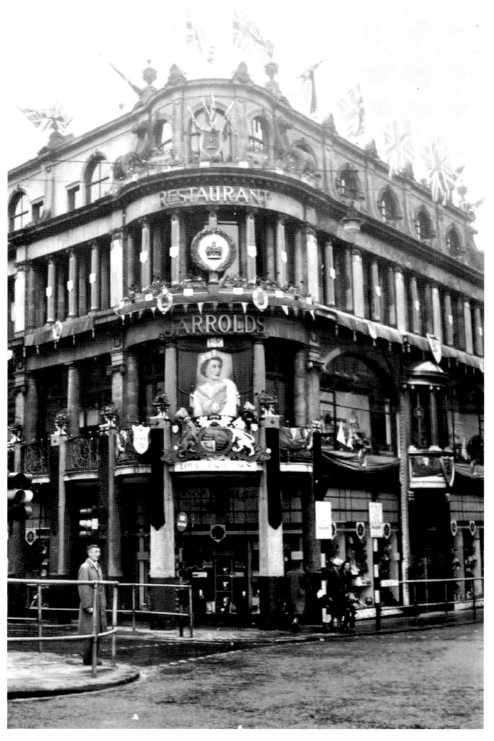

Jarrolds store in full Coronation colours, June 1953. (Photograph by permission of Jarrolds)

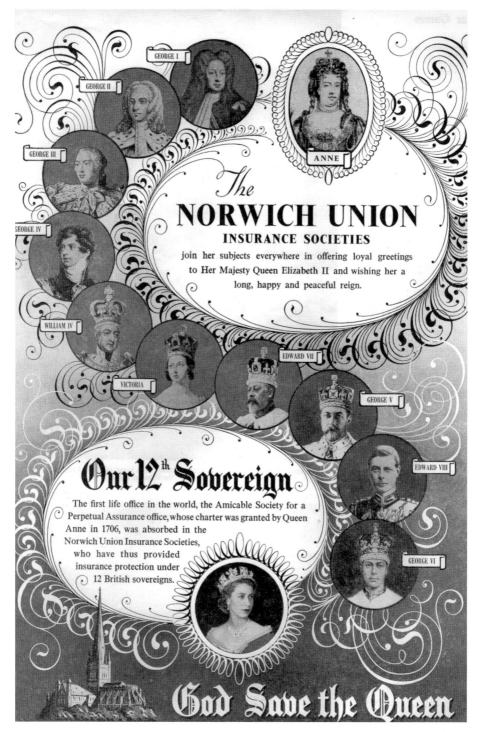

Norwich Union, as it was then still called, took an interestingly historic approach to the Coronation. They advertised on the theme of their own longevity, heralding in the new queen as the twelfth sovereign in the company's history.

5

TO BUSINESS

Norwich is the birthplace of many significant companies. In pre-Aviva days the very name of Norwich Union made its origins clear. Their coronation advertising of 1953 had played to the heritage of the business, and its national standing.

At home in Norwich there was of course the head office of the organisation, but also a local branch.

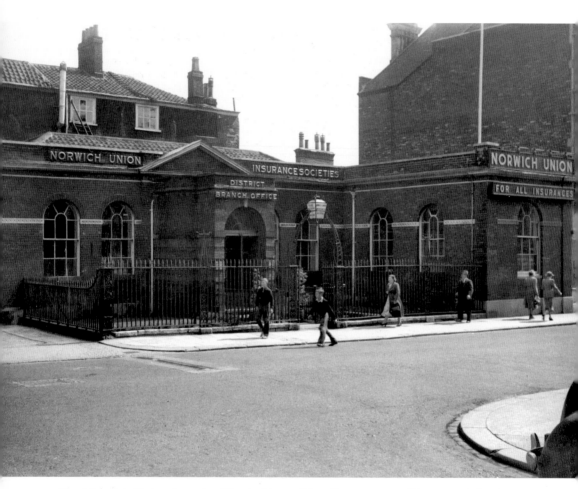

The Norwich Union branch office in Upper King Street, 1954. (Photograph by George Plunkett)

At this time much of Norwich Union's promotional material was produced in Norwich. The origins of this particular campaign are lost but it is absolutely redolent of the 1950s, when it appeared nationally. Just as a brand today needs to promote individual aspects and products of the organisation, Norwich Union, ever-sophisticated marketers, singled out services for advertising campaigns.

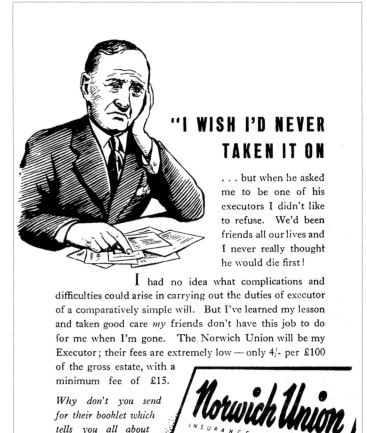

"I WISH I'D NEVER TAKEN IT ON

... but when he asked me to be one of his executors I didn't like to refuse. We'd been friends all our lives and I never really thought he would die first!

I had no idea what complications and difficulties could arise in carrying out the duties of executor of a comparatively simple will. But I've learned my lesson and taken good care *my* friends don't have this job to do for me when I'm gone. The Norwich Union will be my Executor; their fees are extremely low — only 4/- per £100 of the gross estate, with a minimum fee of £15.

Why don't you send for their booklet which tells you all about their Executor and Trustee facilities."

Norwich Union
INSURANCE SOCIETIES
TRUSTEE DEPT.
6-32 SURREY ST., NORWICH. NORFOLK

Norwich Union has been an essential part of the Norwich story and the growth of their head offices is directly linked to some of the visible changes to the city.

One of the Norwich Union buildings, dating from the early twentieth century, had stood in the Bull Lane area at the top of St Stephens. It was demolished to make room for 1950s expansion and redevelopment.

And St Stephens certainly was redeveloped during the decade. In an innovative and swift process, the new buildings were constructed behind the existing frontages. When the old shopfronts were demolished the street was changed almost literally overnight. It was wider and it had a brand-new appearance.

This must have struck a welcome chord with those who had lamented over the aspect that Norwich presented to those arriving from the south. Suddenly, there was a new thoroughfare in keeping with a new decade.

" The Man in the Moon came tumbling down and asked the way to Norwich " 'South' they told him tersely, and this inadequate directive cannot have been much help to the unfortunate visitor, who immediately afterwards met with another disaster when making his first acquaintance with English cookery.

They manage things better round Norwich nowadays. Visitors can be sure of good food and civil answers to their questions. We know the district very well because we have been bankers in East Anglia since 1700. In fact, if you ask a local resident where he banks he is apt to reply (with reminiscent brevity) 'Barclays'; and indeed, gentle reader, whether you come from the Mountains of the Moon or the Mile End Road, you too could do worse than do the same.

BARCLAYS BANK LIMITED

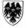 *The Barclays system of Local Head Offices — with Local Directors who really know their districts — means that special attention is given to the differing problems of different localities. There are thirty Local Head Offices in England and Wales.*

Above: 1950s St Stephens Street. (Photograph by George Plunkett)

Left: Another major financial institution to originate in Norwich is Barclays. John and Henry Gurney had founded Gurney's Bank in 1770. The Gurneys of Norwich became hugely wealthy and, despite some complications in other parts of their business empire, hugely respected.

In 1896 Gurney's Bank merged with several provincial banks, and Barclays in London, to create what is today's Barclays Bank.

It seems that in the 1950s Barclays were actively trading on their Norwich origins. This advertisement ran nationally in 1950 and is plainly aimed at promoting Barclays' 'Local Head Offices' where 'special attention is given to the differing problems of different localities'. It's interesting that they went back to their roots to convey the message. Again, the tone of this advertisement is very much that of the decade. Somehow, though, the message has a resonance in the twenty-first century when multinational organisations still need to claim that they deliver local knowledge.

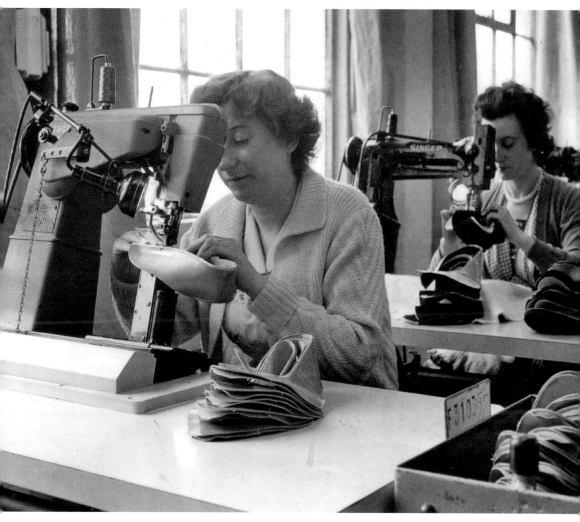

Bally Shoes, Norwich, mid-1950s. (Photograph courtesy of Archant)

Norwich may have been the birthplace of financial organisations, but it will always be associated with shoes. In 1952 the city had 10,000 people working in shoe manufacturing.

That was the year that Norwich company Southall's took a decision that would shape the history of shoemaking. They decided to stop making shoes for adults and concentrate solely on their already successful Start-rite brand of children's shoes. The introduction of 'heel stiffeners' to assist balance and growth, investment in special lasts and the development of a range of width fittings took the brand to new heights. Marketing, under the increasingly famous logo of the Start-rite 'twins', propelled the shoes to national and international fame. The new queen's children wore them, and Start-rite shoes were awarded the Royal Warrant in 1955.

The list of shoe manufacturers in Norwich is impressive, and includes Howlett and White, Norvic, Bally, Sexton, Son & Everard, Southall's, Meadows and Van Dal.

It was in the 1950s that Van Dal recognised the customer need that would define the company's philosophy. Women were asking for shoes that were stylish, but comfortable. Van Dal launched their own range of wider-fitting shoes.

With commendable local patriotism, but perhaps less marketing forethought, the range was originally called The Norfolk Broads. They were renamed after feedback from exports revealed that the name had more than one meaning!

The problem was quickly overcome. Van Dal grew rapidly during the 1950s, acquiring Chittock & Sons Ltd, who also operated from Norwich. Such was the success of the wider-fitting range that the company needed a larger factory and by 1959 they had moved into the Dibden Road site.

The place held by Norwich as the centre of an agricultural county was never in dispute, with farmers using the cattle market regularly and meeting with their lawyers and bankers in its commercial heart. But there were big names on the urban landscape.

In 1956 Boulton & Paul, who had built aircraft during the war, would reorganise to concentrate on standard joinery. The following year they invested in Anglian Building Products, which was associated with Atlas Sand & Gravel, and Norwich Ready-Mixed Concrete.

Laurence Scott, whose origins can be traced back to a commission from Jeremiah Colman in 1883, and who had supplied products to the *Titanic*, were firmly established in Norwich by the 1950s. A major employer, they built a fully up-to-date new factory in 1953, and a new office block in 1957.

Brewers were numerous; mergers and takeovers were not far away but in the 1950s names like Bullards and Steward & Patterson were still important in the city.

The 1950s was a time when manufacturing was still king. Entire families worked at some of the city factories, and the sheer number of employees leaving work at the same time, and usually by cycle, was a significant part of the day's rhythm in 1950s Norwich.

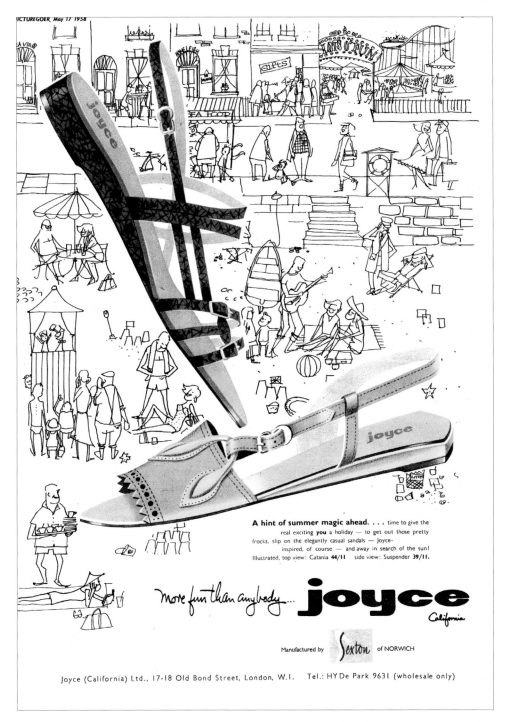

Sexton's of Norwich advertising the 'joyce' range in 1958. The advertisement appeared in *Picturegoer* magazine; that, together with the seriously fashionable graphics, indicates that Sexton's had the 1950s teenage girl as their target audience for these sandals.

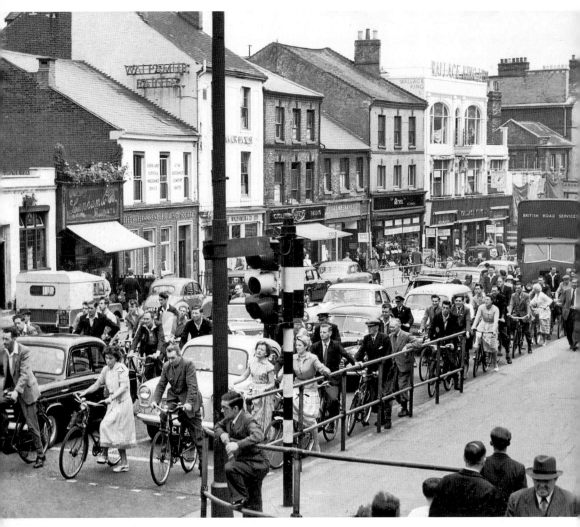

The lunchtime rush, Prince of Wales Road, 1957. (Photograph courtesy of Archant)

The other great product from Norwich, especially during the years of manufacturing dominance, is chocolate. You could smell chocolate in the streets of Norwich. It was in the air. Of all the factories that made sweets in the city, the name that remains on everybody's lips is Caleys.

Often remembered as an independent manufacturer that became merged into the Mackintosh brand, Caleys had in fact been part of the Unilever stable for a period when, in 1932, Harold Mackintosh bought it to gain access to chocolate production.

Norwich has a genuinely important place in the history of confectionery. At one point the Rolo plant was making two tons an hour. The very first Rolo was made in Norwich in 1932. Ten years later, in the same April 1942 raids that had destroyed Curls and Woolworths, the Caleys factory at Chapel Field was destroyed by incendiaries.

Rebuilding was slow, and the plan to create a new factory was not completed until 1952. From that point on the new brands created and manufactured there read like a sweetshop inventory. 1957 brought the launches of Munchies and Week-End. Caramac arrived in 1959, by which time development was in place for Good News Assortment, which went on sale in 1960.

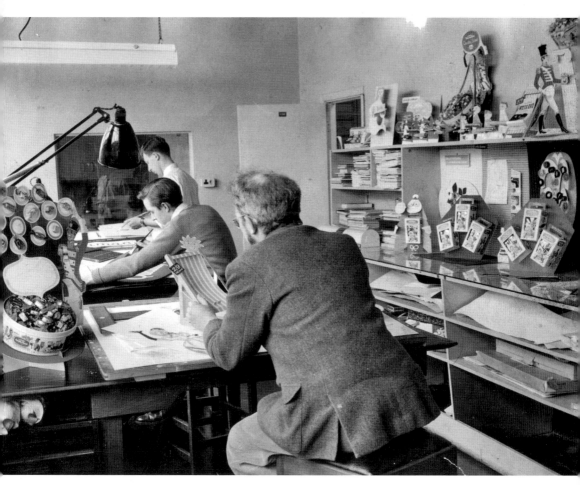

Above and next page: The Fortune brand was earlier, and the Christmas advertisement shown on the following page dates from 1950. However, the graphic style used in this *Illustrated London News* whole page is still clearly evident in the artwork on the desk of the Norwich graphics team in the late 1950s, Quality Street era shot above. (Photograph courtesy of Archant)

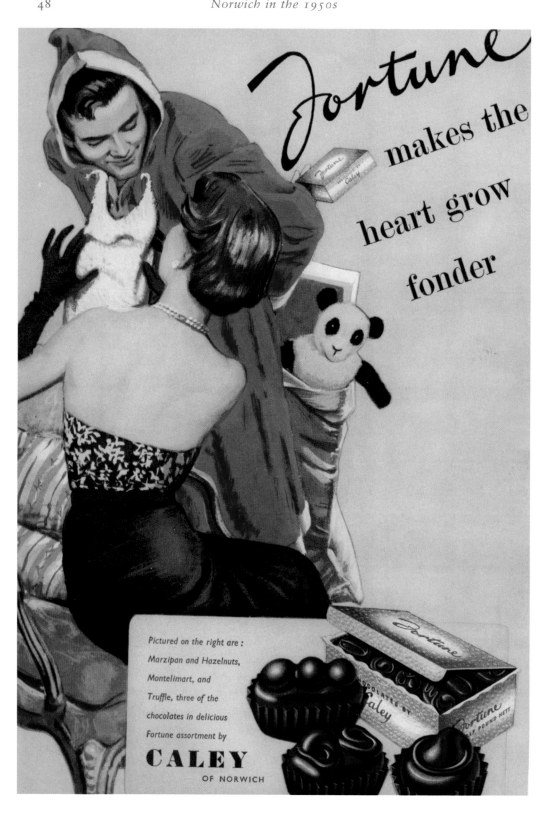

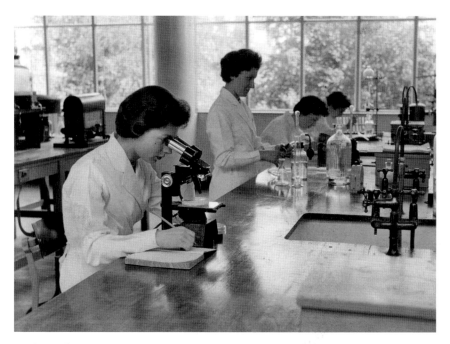

By the mid-1950s companies like Mackintosh's employed huge numbers of people, some of whom were occupied in tasks that had not existed a generation earlier. These earnest young people are in the laboratory at Mackintosh's around 1954. (Photograph courtesy of Archant)

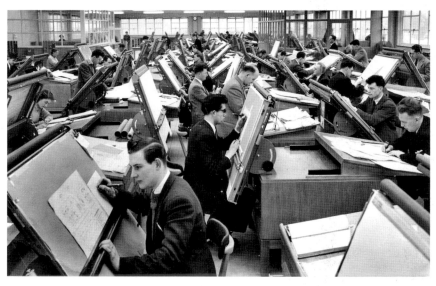

Science may have moved forward, but design techniques were still strictly pencil and ruler. This busy Norwich drawing office in 1957 is staffed by people who have no idea that computer-aided design will arrive in their lifetime. Interestingly, only two women appear in this huge department, while in the laboratory above the team is entirely female. (Photograph courtesy of Archant)

Over at Carrow, the Colman's works was as busy as ever. Less than glamorous, and very much of its time, this shot of the transport depot gives an indication of the size of the operation. This is merely the garage at Colman's.

The Carrow works were a self-contained institution. The philanthropic ideals of the founder remained intact as the company expanded and diversified. Colman's was perhaps the best example of a company where entire families worked, often across more than one generation.

The products made at this site need no real introduction. The mustards are world famous, and the food and drink ranges are household names to this day. (Photograph courtesy of Archant)

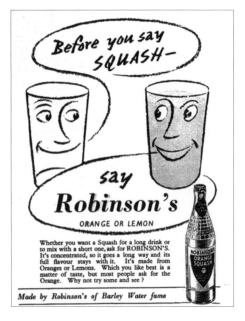

Among the legendary brands from Carrow is Robinson's Squash. The drinks were made in Norwich and advertised nationally. This typically 1950s campaign actually plays one product off against the other.

6
Some Things
Do Change

Some of the changes to Norwich in the 1950s were a direct result of the post-war necessity to rebuild. But tastes, styles and techniques were changing nationally, and Norwich was not to be left behind. Design was very much an issue in the decade that saw the Festival of Britain promote the values and talents of the country as a vibrant, forward-thinking nation.

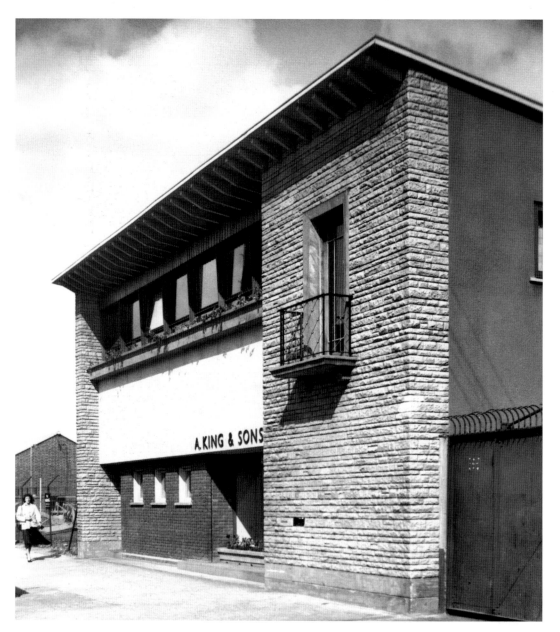

The A. King building on Ber Street shows the new modernity arriving in commercial premises. (Photograph by George Plunkett)

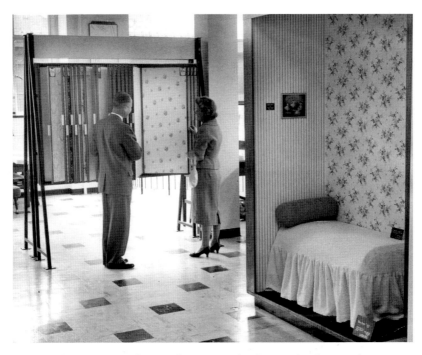

Meanwhile, in Cox's wallpaper showroom, the sheer style of 1950s design is on show for the modern consumer. (Photograph courtesy of Archant)

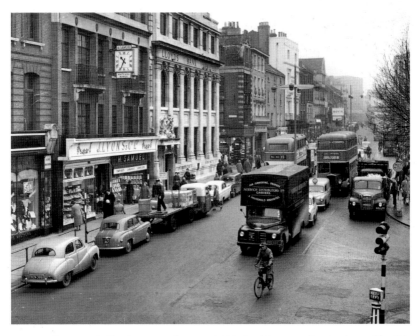

On Gentlemans Walk, the main change visible in this 1958 shot is the traffic. It's busy, but kerb-side parking is still the norm, despite mid-morning deliveries to the shops and the market. (Photograph courtesy of Archant)

Gentlemans Walk in the twenty-first century. The market is still thriving but in a car-free zone.

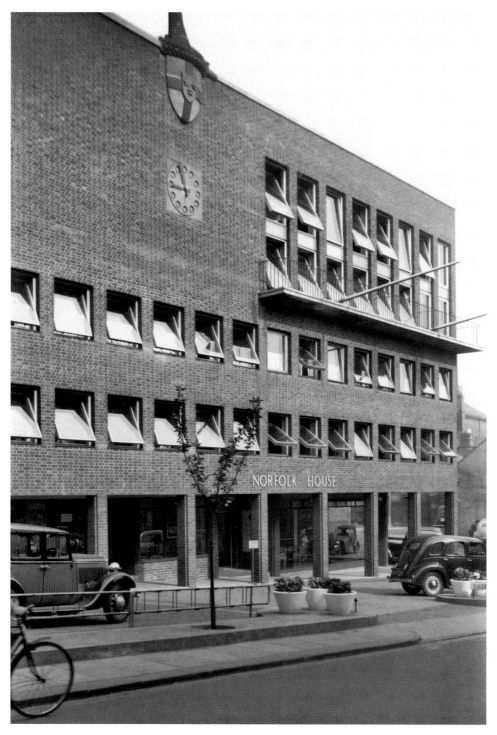

A few hundred yards away, in Exchange Street, the east side of Norfolk House is strikingly more modern. This photograph from 1954 seems to show that at least one car owner is not quite as up to date as the buildings. (Photograph by George Plunkett)

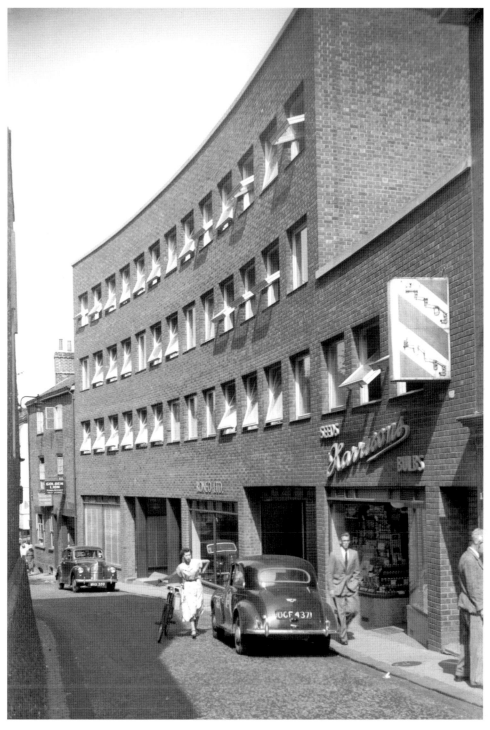

The west side of Norfolk House, also complete by the mid-1950s, gave a new and impressive sweep to St John Maddermarket. (Photograph by George Plunkett)

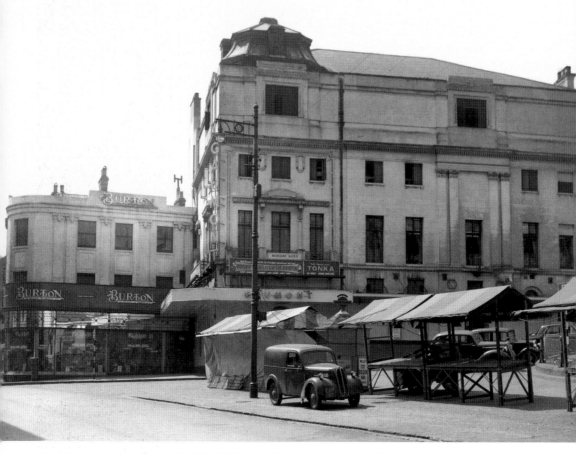

Above: At the other end of The Walk one of the significant developments was the demolition of the Haymarket Picture House. Still intact in July 1959, the plan to remove it was implemented with considerable speed. (Photograph by George Plunkett)

Opposite above: By September of the same year it was already being demolished. With the job half done there's an interesting view into the interior of this once-grand building. (Photograph by George Plunkett)

Opposite below: Orford Place, which would continue to be developed above ground, with the Curls building, was undergoing serious sewerage work in 1953. (Photograph by George Plunkett)

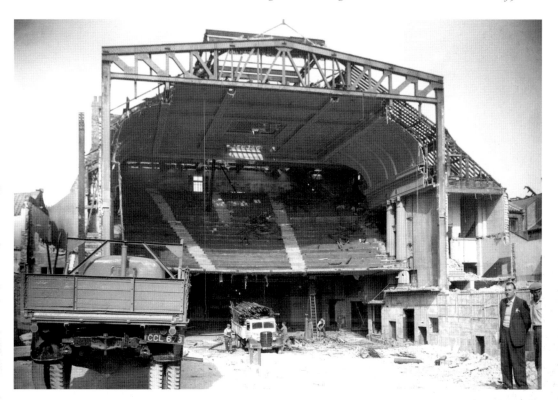

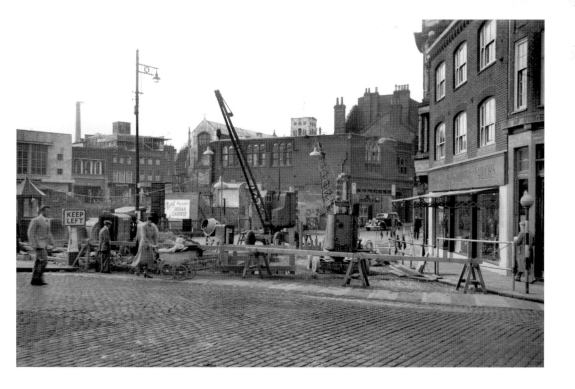

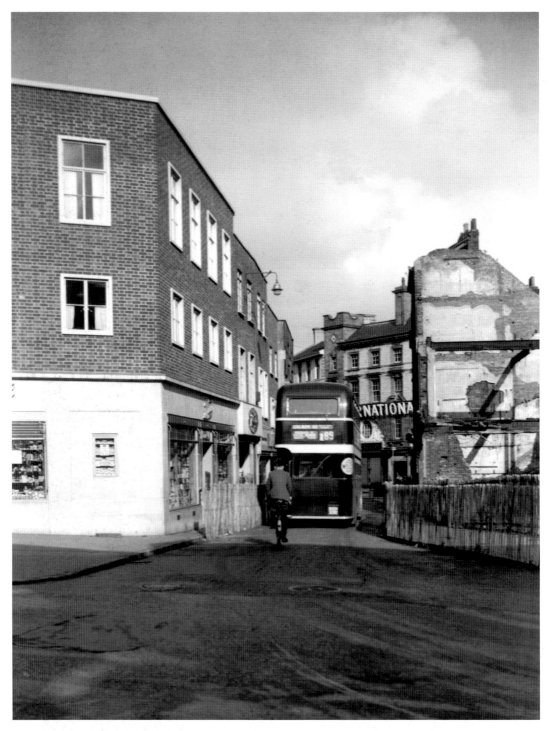

Work was also going on in Brigg Street at the same time, narrowing the thoroughfare considerably. (Photograph by George Plunkett)

By 1955, that dangerous hole behind St Stephens Street had been repaired and Barwells Court looks much more like a modern shopping street. (Photograph by George Plunkett)

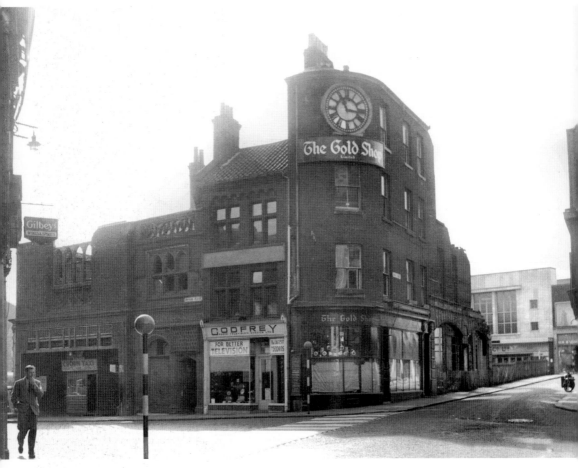

Above: At the junction of Orford Place and Brigg Street, in 1952, there are still damaged buildings. The Crown Taxi company in particular seemed to be operating from less-than-safe premises. Godfrey's are offering 'Better Television' and the latest records. (Photograph by George Plunkett)

Opposite above: By 1954, as this shot shows, work is well in hand. The signage shows that work has commenced on the new Pilch shop. (Photograph by George Plunkett)

Opposite below and following page: Away from the city centre, reconstruction with conservation in mind was underway. In 1955 these cottages in the Gildencroft were being restored. The pictures show before and after the work. (Photographs by George Plunkett)

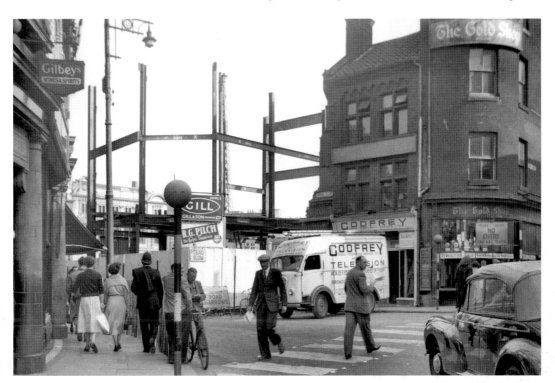

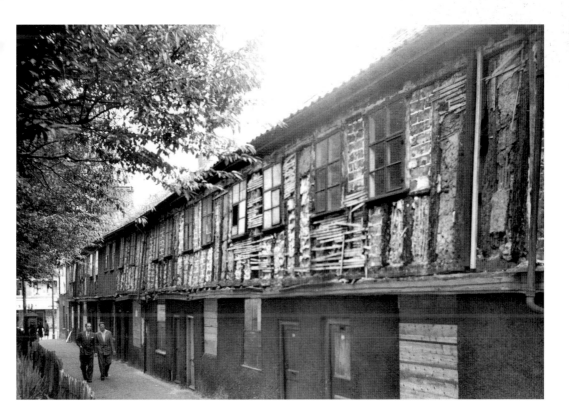

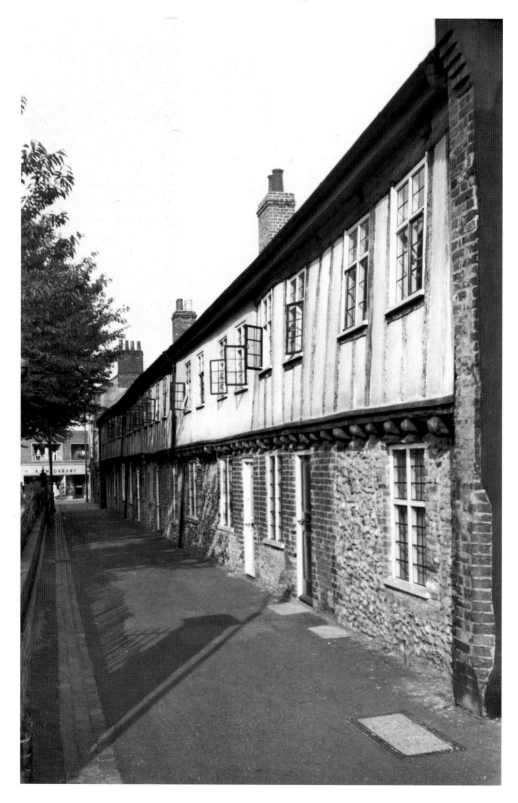

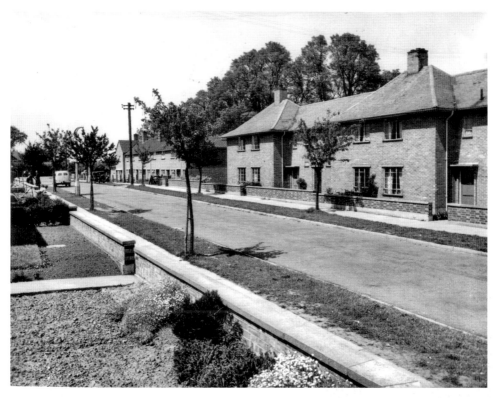

Above and below: Housing was much improved by the 1950s and these pictures show the Tuckswood and Earlham estates in the car-free calm of 1955. (Photographs courtesy of Archant)

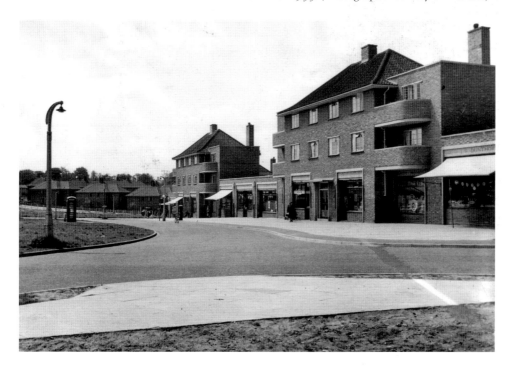

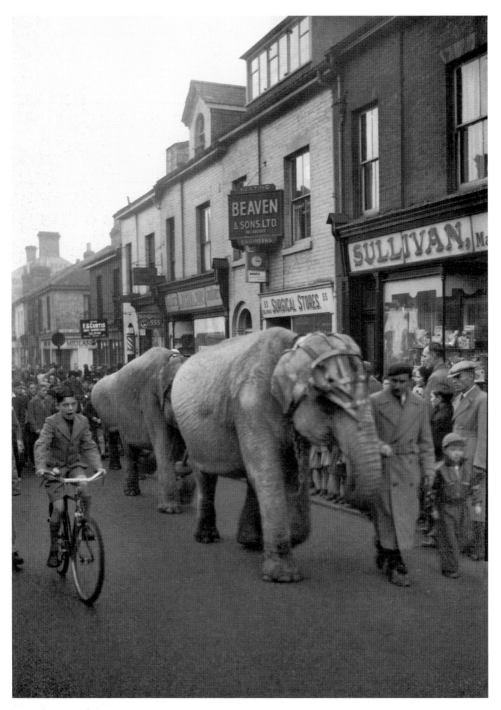

Norwich had long been used to seeing animals and livestock in the city centre; the Cattle Market had been situated there for generations, prior to its move to the outskirts.

But when the circus came to town, animals of rather different breeds were paraded through the streets. It's unlikely that a circus owner of today would undertake such a publicity stunt as this elephant parade in Prince of Wales Road, 1953. (Photograph by George Plunkett)

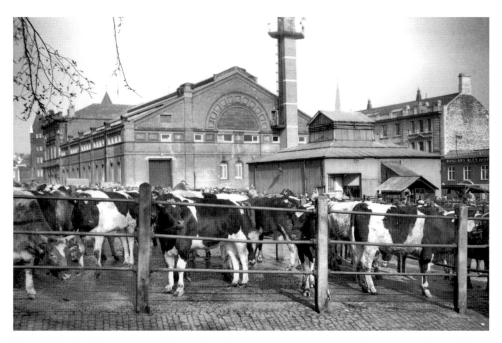

The old Cattle Market was still based in the city centre in the 1950s. Every week livestock was brought into Norwich. It was still working, somewhat incongruously, even after the Agricultural Hall had become a TV studio. (Photograph by George Plunkett)

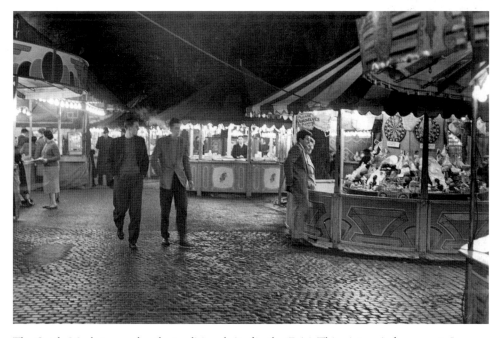

The Cattle Market was also the traditional site for the 'Fair'. This picture is from 1958. In some ways fairgrounds never change, but this shot is very much of its time. (Photograph courtesy of Archant)

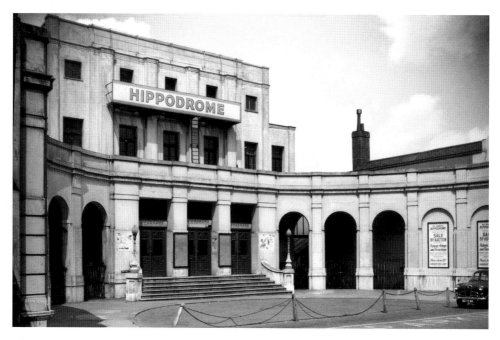

The loss of the Hippodrome was most definitely a change for Norwich. This theatre had been opened in 1903 as the Grand Opera House. Like so many buildings in the city it had been hit during the April 1942 raids. The manager and his wife were both killed.

Although the Hippodrome was open by August 1942, it took years to reconstruct it fully. By the 1950s, though, it was a successful venue again. Big names appeared there, including Max Miller, Morecambe and Wise and that essentially 1950s band of eccentrics, The Goons. (Photograph by George Plunkett)

By 1958 the repairs from the war damage were complete, but audiences were getting smaller. Attempts to relaunch the place as a repertory theatre failed and in June that year the Hippodrome was up for sale. It was closed by 1960, demolished by 1964 and by 1966 it was a car park. Cinemas still thrived in Norwich, and the local music scene was evolving as folk clubs opened in pubs like the Red Lion. Skiffle was all the rage and local groups formed here as they did everywhere.

Ballroom dancing was as popular as ever and the legendary Norman School of Dancing became a regular meeting place for countless young people.

Sport was always popular in the 1950s, as it is today. Perhaps not so high-profile today is Speedway. In Norwich, Speedway was big news.

The Norwich Stars attracted huge crowds to the Firs Stadium at Aylsham Road. Winners of the League Championship in 1950 and 1951, the team were invited into the national League Division One in 1952. Ove Fundin and Aub Lawson are just two of the names from a long list of outstanding riders who wore the Norwich star. Norwich was always amongst the top clubs; sadly Speedway came to an end at the Firs when it was sold for development in 1964.

But when it comes to sport in Norwich in the 1950s, people will always talk about Norwich City, and the 1959 cup run.

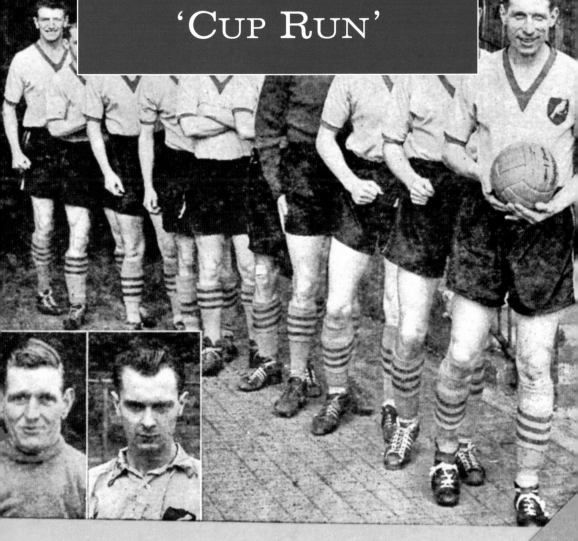

7

THE 1959
'CUP RUN'

What is always referred to as 'The 1959 Cup Run' began of course in 1958. The 1950s had been a decade of mixed fortunes for the Canaries. In 1951 they'd beaten Liverpool, but then lost at Sunderland, to become runners-up in the old Division III (South).

1957 saw the club in financial crisis. The Norfolk News Company, precursor to today's Archant, helped by covering a week's wage bill and a public appeal fund raised £20,000.

In 1958 the Canaries were founder members of the then-new Third Division, but contemporary reports show that there were no serious expectations of glory in that season's FA Cup. In November 1958 they ran out to play Ilford in the first round. With no home win for weeks, they seemed destined to stay off form when, after 27 minutes, they were 1-0 down. And yet, in the second half a certain magic started to develop between City's winger, the Irish Jimmy Hill, and his colleague Bobby Brennan. By the final whistle City were the 3-1 victors and a cautious optimism was emerging.

By the time Norwich had defeated Swindon 1-0 in a second-round replay they already knew that their next opponents would be Matt Busby's 'Babes', the awesome Manchester United. Not only was confidence growing within the team, but public support was swelling beyond hardcore fans. And the national media were starting to take notice.

Ian Woolridge, then sports reporter on the *News Chronicle*, told how he he'd been sent to Norwich on the Friday before the 10 January Manchester game. His job was to interview City manager Archie Macaulay. Woolridge freely admitted that he saw the interview as a formality, and that he had no doubts of Manchester's victory on Saturday.

Then he spent a couple of hours listening to Macaulay. By the time he left Carrow Road that Friday night he was not so sure of the outcome.

He was wise to wonder. But not everybody had the opportunity to hear Macaulay in full flight. The truth was that as 38,000 people filed into Carrow Road on 10 January 1959, there was still, even at this stage, an overwhelming feeling of the game being a chance to see the glamorous, all-conquering Manchester United play. A City win was not a realistic outcome. But it was hoped for.

Ninety minutes later, City weren't country cousins; they were contenders.

As Manchester United reeled from a 3-1 defeat, Norwich City became big news. Bly had scored first. Then Crossan, in the 61st minute. 2 minutes from time Bly scored the third goal, to leave no doubt over the result. Terry Bly's two goals that day gave the *Pink 'Un* the truly wonderful headline – BLY, BLY, BABES.

The 1958/59 Cup was starting to look rather different.

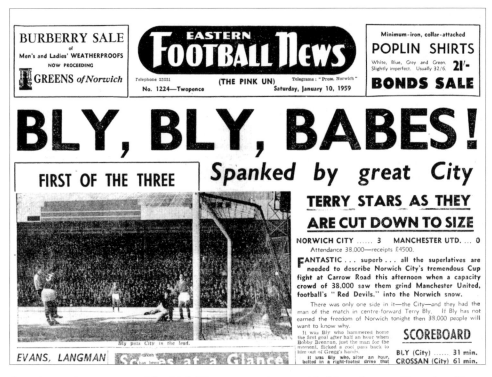

BLY, BLY, BABES!

FIRST OF THE THREE

Spanked by great City

TERRY STARS AS THEY ARE CUT DOWN TO SIZE

NORWICH CITY 3 MANCHESTER UTD. ... 0
Attendance 38,000—receipts £4500.

FANTASTIC . . . superb . . . all the superlatives are needed to describe Norwich City's tremendous Cup fight at Carrow Road this afternoon when a capacity crowd of 38,000 saw them grind Manchester United, football's " Red Devils," into the Norwich snow.

There was only one side in it—the City—and they had the man of the match in centre-forward Terry Bly. If Bly has not earned the freedom of Norwich tonight then 38,000 people will want to know why.

It was Bly who hammered home the first goal after half an hour when Bobby Brennan, just the man for the moment, flicked a cool pass back to him out of Gregg's hands.

It was Bly who, after an hour, belted in a right-footed drive that

Bly puts City in the lead.

EVANS, LANGMAN

SCOREBOARD

BLY (City) 31 min.
CROSSAN (City) 61 min.

Saturday 10 January 1959. The *Pink 'Un* sums up victory with this truly magnificent headline.

It was another all-ticket capacity crowd at Carrow Road on 24 January 1959. Later, some would say that this was the toughest game of the campaign. Even now seen by many as the underdogs, Norwich were buoyed by their ever-loyal and increasingly frenzied fans.

City's performance in that fourth round typified the attitude that sums up so much of what makes Norwich special. The message was clear: 'Underestimate us at your peril'. Cardiff scored first. At the 70-minute mark, both captains had been told by the referee to control their players' tempers; and both teams had two goals. It had been an emotional rollercoaster and tension filled the ground. It was released in a heartbeat when, with 3 minutes to go, Terry Bly did it again. Picking up a pass from Crossan, he slammed the ball into a seemingly impossible gap between the Cardiff keeper and the post.

No cup for Cardiff. The Canaries were flying.

To play Tottenham, away, in the fifth round of the Cup was daunting. But Norwich City were heroes now. Nothing was impossible. More than 20,000 City supporters travelled to London that day. Their elation was palpable when, with moments to play, the Canaries were 1-0 up. Norwich voices were ready to roar in victory when Cliff Jones equalised for Spurs.

As was the way in the 1950s, within hours the *Pink 'Un* was out. It said it all.

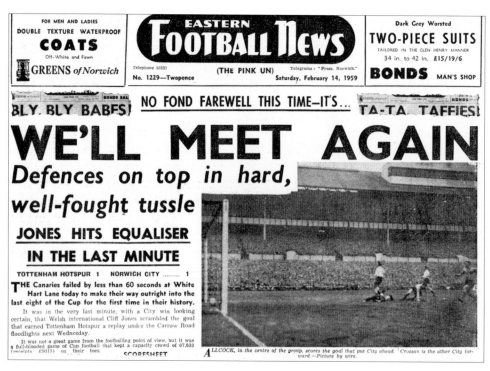

EASTERN
FOOTBALL NEWS

No. 1229—Twopence (THE PINK UN) Saturday, February 14, 1959

Telephone 23321 Telegrams : "Press. Norwich."

BLY. BLY. BABES! NO FOND FAREWELL THIS TIME—IT'S... TA-TA. TAFFIES!

WE'LL MEET AGAIN

Defences on top in hard, well-fought tussle

JONES HITS EQUALISER
IN THE LAST MINUTE

TOTTENHAM HOTSPUR 1 NORWICH CITY 1

THE Canaries failed by less than 60 seconds at White Hart Lane today to make their way outright into the last eight of the Cup for the first time in their history.

It was in the very last minute, with a City win looking certain, that Welsh international Cliff Jones scrambled the goal that earned Tottenham Hotspur a replay under the Carrow Road floodlights next Wednesday.

It was not a great game from the footballing point of view, but it was a full-blooded game of Cup football that kept a capacity crowd of 67,633 (receipts £9315) on their toes. **SCORESHEET**

ALLCOCK, in the centre of the group, scores the goal that put City ahead. Crossan is the other City forward.—Picture by wire.

The attitude is obvious. 'Bring it on!'

The replay at Norwich was a highly charged affair. The by-now-inevitable capacity crowd was in full throat. John Bromley, reporter for the *Daily Herald* would later recall, 'Never shall I forget the replay at Carrow Road. 38,000 fans singing "On The Ball City" had more emotion in it for me than a Welsh crowd singing "Land Of My Fathers" on the final day of the Empire Games when they were told that Prince Charles was the new Prince of Wales.'

It wasn't easy, but it was decisive. 63 minutes in the Norwich skipper, Ron Ashman, chipped the ball to Bly who added another goal to his cup run tally. Spurs, even with Danny Blanchflower brought in, looked defeated from that moment. For Norwich, Wembley was now a real possibility.

The sixth round of the Cup would see another draw and another replay. Away to Sheffield on 28 February, Norwich City were shocked by a 2nd-minute goal, and remained 1-0 down until equalising in the 75th minute.

There had been tension when the authorities at Sheffield wouldn't let the Norwich City mascots on to the field. It had achieved nothing except an increase in volume as 'On The Ball City' swelled over Bramall Lane. There had been heroism as city keeper Nethercott played on with a dislocated shoulder. But it was all back to Norwich for a replay.

It was 4 March. Imagine the pressure on Sandy Kennon, making his first-team début for City as he replaced the injured Nethercott. Imagine the expectations of a city that now worshipped 'the City'.

Norwich were two-goal leaders at one point. Pace scored for Sheffield, making it 2-1. The ground went wild as Bly scored City's third, but Sheffield were dogged opponents. They scored once more. But again, Norwich were through.

It was the semi-final. Support for the team was immense by now. The local media and businesses were behind them. The national media couldn't ignore them. Yellow and green was everywhere.

At their first meeting, Norwich City and Luton Town had drawn 1-1. They'd played at White Hart Lane, and City fans used their experience from the recent visit to gain the best vantage points. An unusual incident occurred before the kick-off when fans noticed that the programme stated there would be extra time played if the scores were equal at 90 minutes. City chairman Geoffrey Watling and manager Archie Macaulay went to the secretary of the Football Association. It was, he said, a mistake.

Pre-match excitement was fuelled by 'Dick and the Dumpling', the Norwich mascots whipping up the crowd. There had been no issues over their appearance this time. And, in what was a rather revolutionary move for 1959, they were accompanied by 'women mascots, one of them draped in a yellow and green robe'.

The only time the Luton fans made more noise than those from Norwich was when they were led onto the field by their veteran centre-half Sid Owen. As that cheer faded away, the strains of 'On the Ball City' swelled again and again, ever louder, ever more passionate.

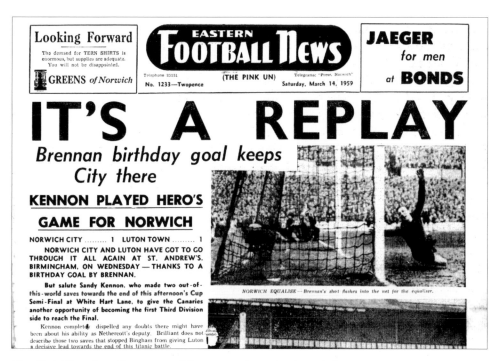

The *Pink 'Un* salutes Brennan and Kennon as the replay is settled.

They changed the song briefly to sing 'Happy Birthday' to Bobby Brennan.

He was to celebrate it in style. The crowd went wild as his 65th-minute goal equalised for Norwich and forced the replay.

The arrangements for the replay at Birmingham provide an interesting snapshot of life in the 1950s. Tickets were to be on sale at Carrow Road from 9.30 a.m. on Sunday 15 March, the day after the Luton draw. Season ticket holders could purchase tickets at 21s, 15s, 10s and sixpence or 7s and sixpence until the Tuesday.

Otherwise tickets were priced at 2s and sixpence, limited to one per person, and the Norwich allocation would be under 18,000.

These prices (2s and sixpence being equivalent to 12½ pence) give some context to the economics of the game at this time. Those 38,000 capacity gates at Carrow Road had been swelling the City coffers to the tune of £6,000!

The *Pink 'Un*, in its Saturday 14 March edition, the day of the 1-1 draw at White Hart Lane, was already publishing details of not only the Wednesday night replay, but the travel arrangements for getting to Birmingham to see it.

'It is hoped that if the match is drawn supporters will buy their tickets for these trains as soon as possible after they arrive back from Tottenham,' it proclaimed.

The trains in question were a first-class restaurant car service at 42s (that's £2 10p for a first-class return from Norwich to Birmingham!) and a 24s second-class return, with buffet car, leaving Norwich at 8.48 a.m.

Eastern Counties Omnibus Company had moved quickly too, announcing plans for a 22s return.

Throughout the cup run the local press, especially the *Eastern Football News*, known to all as 'The *Pink 'Un*' had given full voice and support to the Canaries.

He deserves the best—and he's got it

GARDEN STREET
CROMER
Tel. Cromer 2651,

Tom Watts

KING STREET
NORWICH
Tel. 29175-6-7

Local commerce showed its support too. From greenhouses to furniture, the local advertisers found ways to add a football twist to their messages. Inevitably and understandably the TV and radio retailers promoted their wares to those who couldn't get to the games. Local brewers wished the club well, and even the national brands now saw the size of the City phenomenon.

Made up on the Dutch Light principle, ready for easy assembly. Selected timber treated with wood preservative. Glass slides in—no putty needed. Easily dismantled for moving.

These glasshouses are now made to an improved specification, giving increased thickness, extra braces, galvanised capping, etc.

		Redwood	Cedar
3 BAY—Approx	8' x 8'	£28-10-0	£37-10-0
4 BAY—Approx	10' x 8'	£31- 0-0	£40- 0-0
5 BAY—Approx	13' x 8'	£33-10-0	£42-10-0

Prices include glass cut to size Delivery ex works

WE WILL ERECT IF REQUIRED, AT A SMALL EXTRA CHARGE

JEWSON

COLEGATE Tel. 21336 (10 lines) NORWICH

Branches at Gt Yarmouth, Lowestoft, Dereham, Fakenham, Diss, etc.

Right and below: 14 March 1959, and local businesses from greenhouses to furniture are supporting the City, usually with ingenious links to football.

CONGRATULATIONS CITY !

ON A MAGNIFICENT PERFORMANCE !

YOU CAN HAVE A GRAND STAND SEAT AT WEMBLEY FOR ONLY
WITH A BRAND NEW TELEVISION

£2
DEPOSIT

9'- weekly (Reducing) will give you " All Year Round " viewing with all Service, Tubes and Valves Free of Charge on our ' Unbeatable " Rental Scheme.

TELEVISION CENTRE

(TUMILTY ELECTRIC LTD.)

20 Wensum Street, Norwich, Tel 22117. 62 St. Giles Street, Norwich
Market Place, Diss, Tel. 2467. Market Place, North Walsham, Tel. 3260

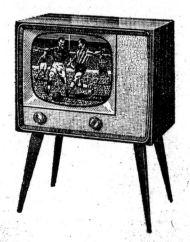

Above: Obviously the TV and Radio shops have their say.

Opposite: Local brewers lend their support.

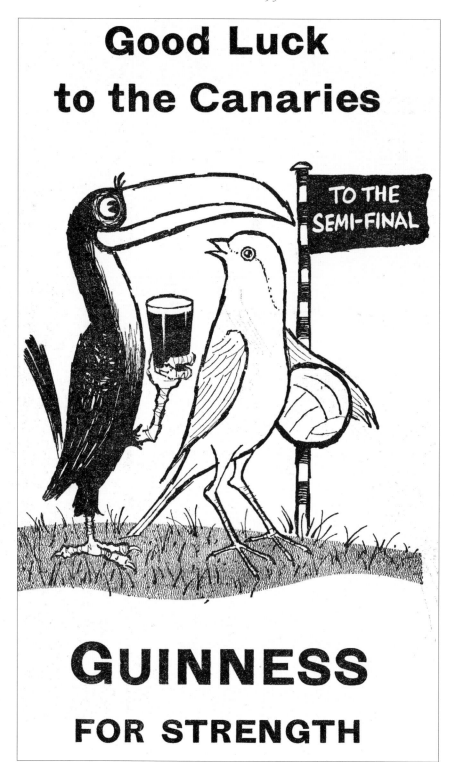

And even the mighty Guinness put their toucan in touch with the Canary.

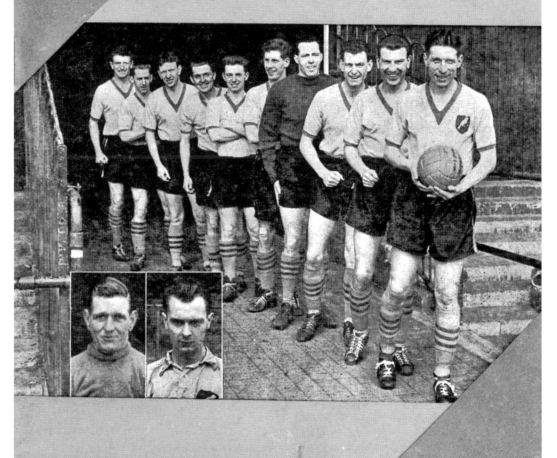

CANARY CRUSADE

Edited by TED BELL, Sports Editor,
"Eastern Daily Press" and
"Eastern Evening News"

PRICE

2/-

The ever-supportive Norfolk News Company produced a handsome tribute in the form of *Canary Crusade*.

18 March 1959 would be City's eleventh game in the cup and the end of the road. Norwich worked hard in the first half, narrowly missing the goal at least twice.

In the 56th minute Luton scored. It was said that from that moment there was a sense that it was all over. But nobody could deny that Norwich went down with all colours flying. They'd come further than anybody had expected them to, and they'd captured the hearts of thousands.

The Canary dressing room received no visitors for over half an hour after the final whistle. But this was Norwich. They came home to a hero's welcome. The cup was not to be theirs, but they had the glory.

But perhaps the final word goes to the cartoon from the *Pink 'Un*. Dick and the Dumpling spoke for everybody in Norwich.

8

THE MEDIA

The Norwich newspapers had been immensely supportive of Norwich City, bailing them out of financial crisis in 1958 and shouting loudly throughout the cup run. 1959 was to be a big year for them too.

The *Eastern Daily Press* and the *Eastern Football News* were then owned by the Norfolk News Company. Founded by Jacob Tillett, Jeremiah Colman, John Copeman and Thomas Jarrold in 1845, the company had published a Norwich-based newspaper which had developed into the *Eastern Counties Daily Press*. This would soon drop one word from its title to become, in 1870, the now familiar *Eastern Daily Press*.

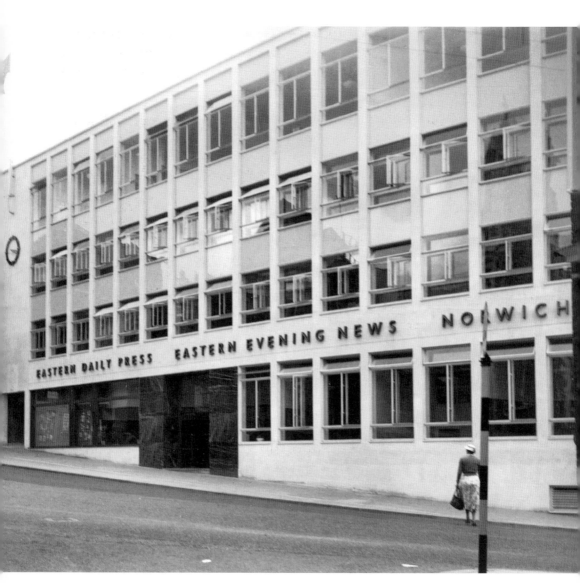

The new *Eastern Daily Press* building, August 1959. (Photograph by George Plunkett)

Always innovative with technology, even in the very early twentieth century, the *Eastern Daily Press*, and its sister, the *Eastern Evening News* were, by the 1950s, an essential part of Norwich life.

These papers would tell the story of the city and its region throughout the decade, as they do to this day.

Early in the 1950s it had been their task to report on the dreadful floods of 1953, a catastrophe that would shake the county.

They would make history in 1956 when the editor-in-chief, Stanley Bagshaw, who had been aide to General Montgomery during the war, welcomed Soviet leaders Bulganin and Kruschev to Norwich. He ran the editorial in Russian. He did, however, include a translation.

It was in 1957 that the back page was to change, becoming eventually the sports page. By 1959, the *EDP* was facing industrial action. News was put out on duplicated sheets in the June and July. By August 1959 the company had moved to their new premises in Redwell Street.

The building looked every bit the new face of 1950s commerce.

Just around the corner, in a more traditional building, a less traditional medium was arriving in Norwich. It was Anglia Television.

ITV had been broadcasting in Britain since 1955, empowered by the 1954 Television Act, which allowed for television services other than those from the BBC.

ITV had started in London, but the national spread was soon underway and the invitation to tender for the eastern England franchise was issued. Norfolk farmer Lord Townshend quickly assembled an impressive team to meet the challenge. Notably William Copeman, head of the *Eastern Daily Press*, came on board, as well as Laurence Scott, bringing his important credentials from the *Guardian* newspaper. Romulus Films, who had made *The African Queen* with Humphrey Bogart, joined. So too did Sir Robert Bignold, proving the point he'd made to 'Mr Dimbleby' seven years earlier, that Norwich was indeed progressive.

Sir Peter Greenwell, from Suffolk, was part of the team, which also included the head of a London-based theatre company, a conservationist, and academics from Cambridge.

Events moved quickly. Anglia Television, as the company had called itself, won the franchise and established offices in the Agricultural Hall, a building that had also featured in Dimbleby's 1952 film. Now it had a new lease of life.

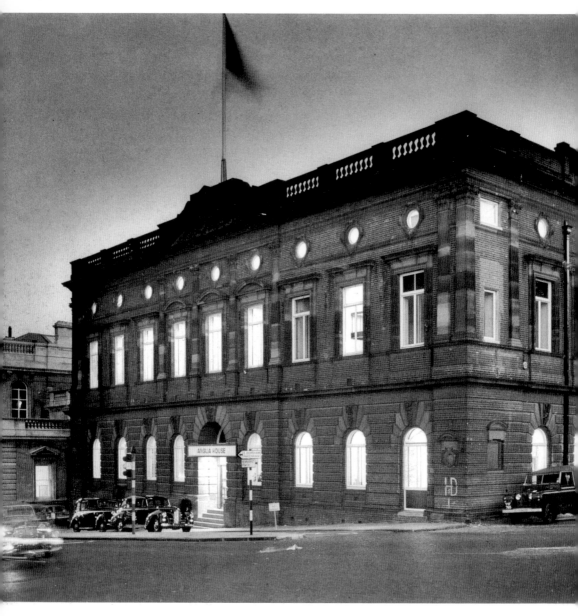

Anglia TV opens its doors: Anglia House, 1959. Work soon began on converting the building into studios. Soundproofing was achieved by effectively creating a new building inside the original outer structure. It was an impressive achievement. While all of the studio work was in progress, separate teams were constructing the transmission mast at Mendlesham. The Mendlesham transmitter was the tallest in Europe, weighing in at 180 tons. (Photograph courtesy of Archant)

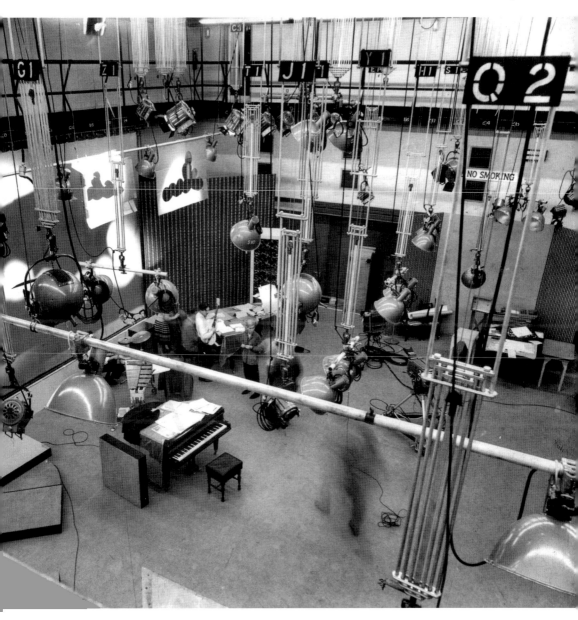

The new Anglia TV studios, 1959. (Photograph courtesy of Archant)

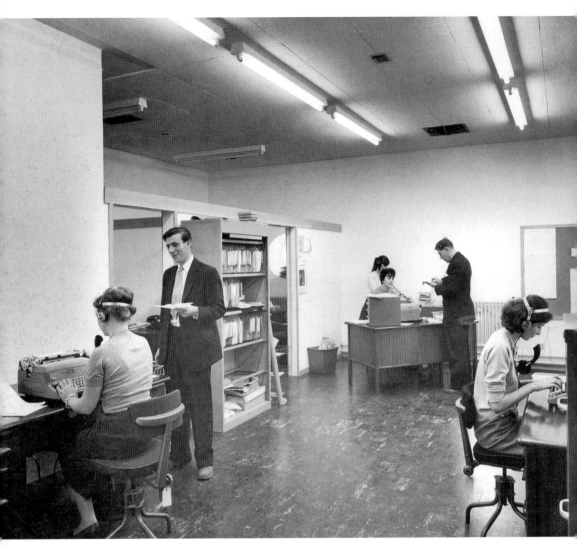

Staff in place and production begins, Anglia TV, 1959. Running up to the launch, over 300 staff were recruited to meet the need for journalists, technicians, secretaries and presenters. (Photograph courtesy of Archant)

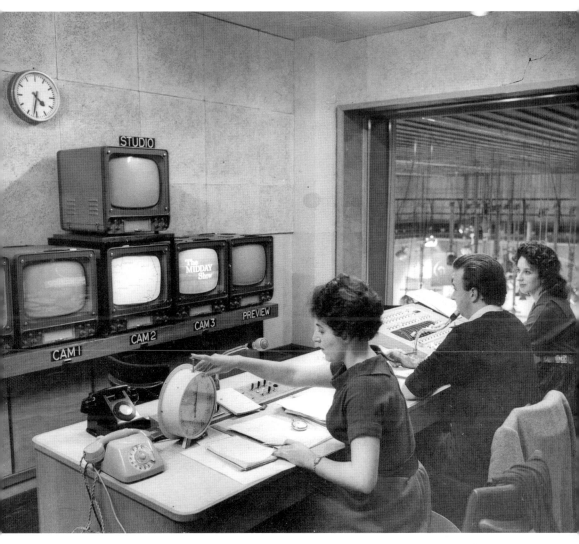

By October they were ready and Anglia Television made its first broadcast on 27 October 1959.
(Photograph courtesy of Archant)

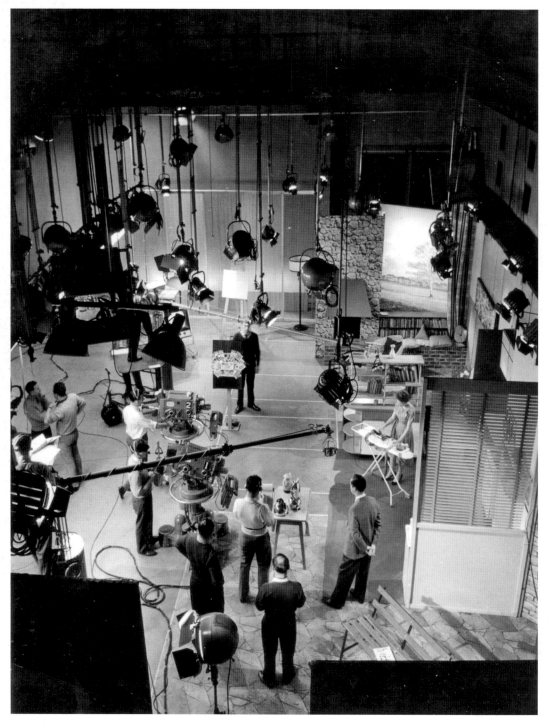

Anglia Studios, ready for broadcast, 1959. (Photograph courtesy of Archant)

9

THE CITY AT LARGE

With a modern newspaper company, a brand-new TV station and highlights such as the 'Cup Run' and the Festival of Britain, it's not difficult to paint a picture of Norwich as a bright new city in the 1950s.

In some places, though, it seemed that progress was moving at a different pace. There had already been much speculation about the Magdalen Street area. The 1945 Plan had specifically mentioned it, not only proposing its pedestrianisation, as a precinct, but going so far as to say that this was 'the only alternative to its destruction and the consequent loss of one of the most typical older streets'. It was seen as 'one of the most dangerous streets in the city, with an average accident rate of nearly a hundred a year'.

The plan was in effect to bypass the street with a carriageway to the east of it, complete with bus stops and car parking. People getting out of buses and cars in the 'new street' would be only 50 yards from the old one, giving shopkeepers, as the 1945 Plan said, 'the benefit of windows on both [sides] as is now the case in certain shops between London Street and Castle Meadow'.

The Plan went on to say, in a frank admission, that the concept was 'not regarded as ideal from the traffic point of view, but as the best solution obtainable in the circumstances'.

It was 1963 before the Magdalen Street flyover was approved, and in the meantime Magdalen Street received a facelift in the 1950s from the Civic Trust.

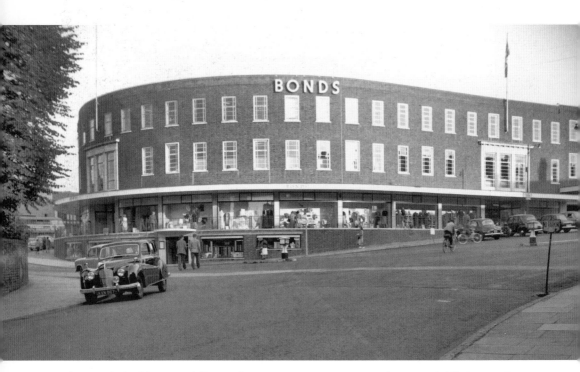

The Bonds building, so different from its pre-war ancestor, dominated All Saint's Green. (Photograph by George Plunkett)

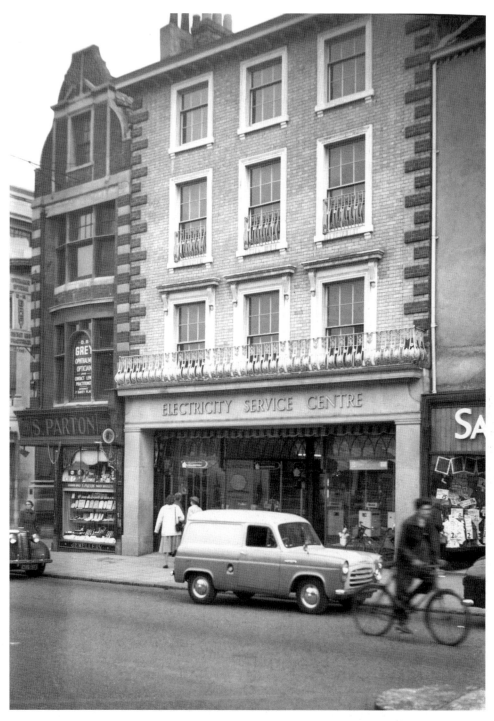

Gentlemans Walk was busy and the post-rationing world of electrical appliances was there to be had in new retailers like the 'Electricity Service Centre'. The Eastern Electricity Board had been formed in 1948 as part of the nationalisation of the electricity industry, and many a new home in Norwich would acquire its first cooker from their showrooms. (Photograph by George Plunkett)

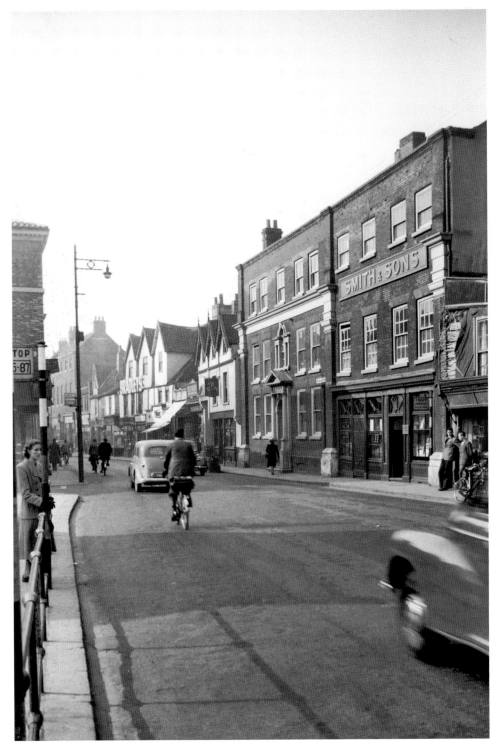

Magdalen Street, 1951. (Photograph by George Plunkett)

Magdalen Street, 1950. (Photograph by George Plunkett)

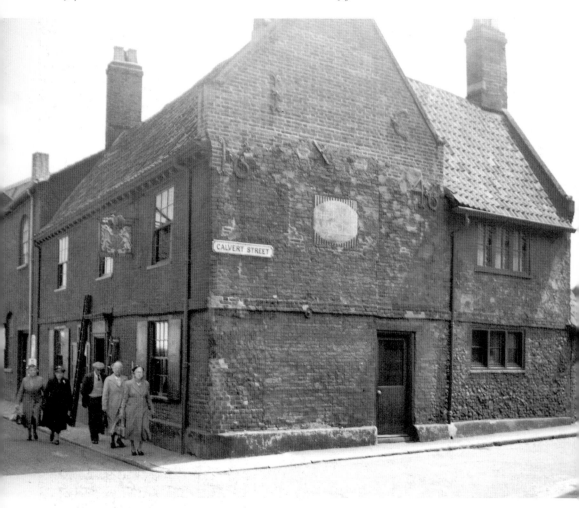

Above: The King's Arms, 1956. As the facelifts and makeovers reshaped Norwich for the 1950s, much of the city remained unaltered. Just behind Magdalen Street the King's Arms, on the corner of Calvert Street, looks resolutely unchanged in this 1956 shot. (Photograph by George Plunkett)

Opposite: Old Bank of England Court, 1954. In other corners there were buildings, castle and cathedral aside, that retained a charm from a bygone era. Some changes are less conspicuous to the modern eye, and memories fade as new generations are unaware of what went before.

This picture of Old Bank of England Court shows the square much as it stands today, except for the building on its north-west side, demolished in 1954. (Photograph by George Plunkett)

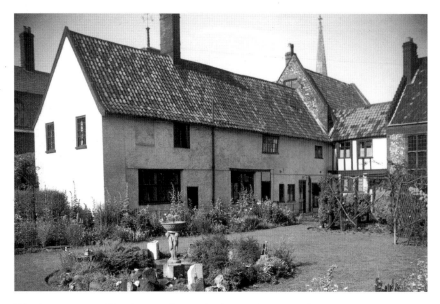

The Great Hospital kitchen garden is timeless in this 1950 photograph. (Photograph by George Plunkett)

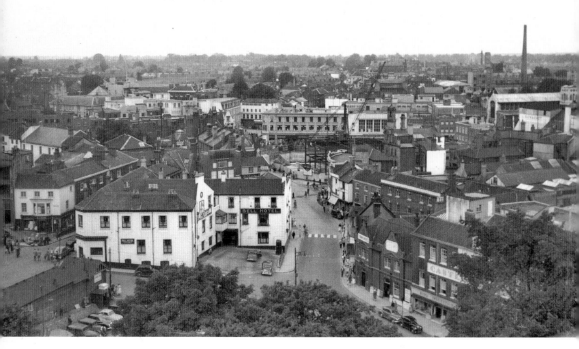

George Plunkett's view of Norwich, taken from the castle in 1954. This one picture embraces much of what this book has covered. The city is, at first glance, familiar to modern eyes. A closer look reveals changes taking place; changes that would characterise the 1950s.